TREASURES
OF
FYVIE

4 July–29 September 1985
Scottish National Portrait Gallery
Queen Street, Edinburgh

SPONSORED BY

CHARTERHOUSE

A member of The Royal Bank of Scotland Group plc

Designed by HMSO Graphic Design
Printed in Scotland for HMSO. 6/85
ISBN 0 903148 59 5

FOREWORD

Last year the great Aberdeenshire Castle of Fyvie and its treasures became the Nation's property. The sale to the National Trust for Scotland, made possible by a most generous grant from the National Heritage Memorial Fund, ensures its preservation and the public's access to, and enjoyment of, the Castle.

This exhibition, organised by the Scottish National Portrait Gallery, celebrates that purchase. It also celebrates the many individuals, architects, artists, and craftsmen who have created Fyvie over the centuries. Most closely connected with the Castle have been the great families in whose ownership Fyvie remained until last year, the Prestons, the Meldrums, the Setons, the Gordons and the Forbes-Leiths. The laird of Fyvie, Sir Andrew Forbes-Leith, has very kindly lent several paintings to this exhibition (nos 12, 13, 62, 63, 65 and 66). They will return to Fyvie to be shown to the public with the rest of the collection.

The staff of the National Galleries of Scotland would like to record their thanks to the National Trust for Scotland for their willingness to let the best of Fyvie's paintings, furniture and armour be seen in Edinburgh while the house is prepared for public access. Thanks are also due to the merchant bankers, Charterhouse, who have so generously sponsored the exhibition. I should also like to thank Richard Emerson who provided the interesting account of the architectural development of the Castle, James Holloway of the Portrait Gallery who organised the exhibition and who describes the formation of the Fyvie art collection as well as writing the majority of the catalogue entries, and Duncan Thomson, Keeper of the Portrait Gallery who wrote the entries for the notable collection of Fyvie's Raeburns.

They in turn would like to acknowledge the help they have received from their colleagues and from the following in particular: Anne Ambler, US Steel International, London; John Batty, National Trust for Scotland; Hugh Cheape, National Museum of Antiquities of

Scotland; Elizabeth Einberg, Tate Gallery; John Gifford, Buildings of
Scotland Research Unit; Ian Gow, Royal Commission on the Ancient
and Historical Monuments of Scotland; Christopher Hartley,
National Trust for Scotland; Mark Jones, British Museum; Alex
Kidson, Walker Art Gallery, Liverpool; Richard Kingzett, Thomas
Agnew & Sons Ltd, London; A Lammie; David Learmont, National
Trust for Scotland; Nancy Little, Knoedler's, New York; J M Mindek;
Charlotte Neilson, National Trust for Scotland; Graham Pollard,
Fitzwilliam Museum, Cambridge; Roger Quarm, National Maritime
Museum, Greenwich; R B Raworth; Jacob Simon, National Portrait
Gallery, London; Rab Snowden, Stenhouse Conservation Centre; Dr
David Stuart; Robert Storey, Fyvie Castle; the Honble Michael
Tollemache; David Walker, Scottish Development Department, Historic
Buildings and Monuments Directorate; Sir Ellis Waterhouse; Stephen
Wood, Scottish United Services Museum; Frank Zabrosky, University
of Pittsburgh.

Timothy Clifford
DIRECTOR
NATIONAL GALLERIES OF SCOTLAND

SPONSOR'S FOREWORD

The Fyvie collection owes its existence to the determination and entrepreneurial skill for which Scots, emigrating to the New World in the nineteenth century, became renowned. Just like Andrew Carnegie and Allan J Pinkerton, Alexander Forbes-Leith, the founder of the collection, never forgot his Scottish roots. Having made his fortune in the US steel industry, he returned to Scotland, bought the Castle of Fyvie and determined to build up the small art collection it then housed.

It seems appropriate to us that one of Scotland's oldest financial institutions should help the Scottish National Portrait Gallery to display Fyvie's riches. It is reasonable to assume that more people will see and enjoy the collection during the course of the exhibition than has been possible in the last hundred years.

As the newest member of The Royal Bank of Scotland Group, we at Charterhouse are delighted to be associated with this exhibition, 'Treasures of Fyvie'.

John B Hyde
CHAIRMAN AND CHIEF EXECUTIVE
THE CHARTERHOUSE GROUP plc

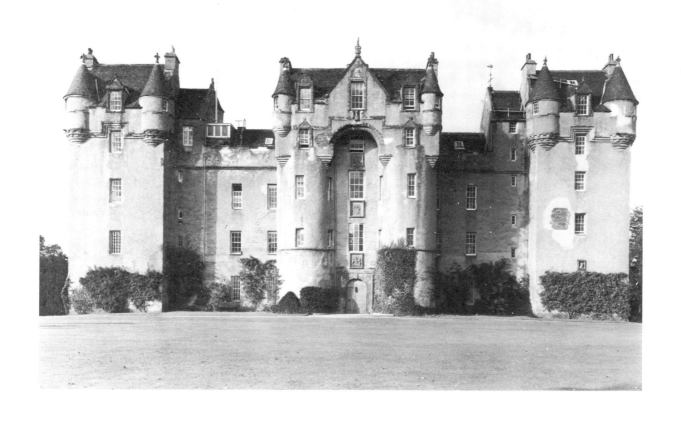

THE BUILDING OF FYVIE CASTLE

Today Fyvie Castle is defended only against the curious — a high wall running for miles along the side of the road from Aberdeen to Banff and the tall thick woods of the nineteenth-century park, cloak all but the rooftops of the house from public view. Even within the walls, the long drive skirting the lake is contrived to keep the house hidden until the last possible moment. These armies of trees, ramparts of rhododendrons and the moat of the lake, overlay an earlier, but no less defensive landscape centred on the Castle, which is set on a natural mound above a bend in the River Ythan that protects its west and north flanks. To the east, the lake was once a boggy marsh, obliging any approach or attack to be made from the south. The defensive possibilities of this site had been obvious from at least the thirteenth century, when Fyvie, a royal property, was the capital Messuage of the Thanage of Fermartyn, the central area between the Rivers Ythan and Don, and played its part in housing the largely peripatetic medieval monarchy. William the Lion was here in 1211 or 14 and Alexander III granted a charter at Fyvie on 22 February 1222. Less welcome was the English King, Edward I, who was at 'Fyvin Chastel' on Saturday 21 July 1296.

During the fourteenth century, the Castle continued to be held by the Crown until 1370, when Robert II granted it to his elder son, John, Earl of Carrick, later Robert III. He in turn granted the Castle to his cousin Sir James Lindsay, Earl of Crawfurd and Buchan in 1380. Until this point, the available documentary evidence sheds no light on the form of the Castle at Fyvie. But in 1385, Margaret Keith, wife of Sir James Lindsay, was besieged at Fyvie by her nephew Robert Keith, and Wyntoun's description of the siege provides the first written evidence of stone buildings at Fyvie:

> For his masownys fyrst gert he
> Fra thar werk remowide be;
> And quha that wattir broucht fra the burne
> He gert thaim oft withe his ost spurne

7

Thus he demaynit that Lady
Withe in the Castel of Fiwy.

What the masons were working on is not recorded.

In 1390–1 the lands of Fyvie were re-assigned by Robert III to Sir Henry Preston, Sir James Lindsay's brother-in-law, in redemption of 'Ralph de Percy, English Knight', captured at the Battle of Otterburn in 1384. This was apparently a business transaction by which Robert III bought out Sir Henry Preston's interest in the ransom of Ralph de Percy, but it was not until 1402 that Preston obtained possession.

Preston's contribution to the building's evolution is as unclear as that of his son-in-law and successor, Alexander Meldrum, who inherited the castle in 1433. Whilst the association of the name 'The Preston's Tower' with one of the towers is noted as early as 1732, no such tradition links the Meldrums with the west tower, which seems to have gained its title in a wholesale, mid-Victorian naming of parts – quite literally in the case of the bedroom doors and servants' bell boards – Dunfermline, Gordon, Tifty, Formartine etc – designed to aid house-guest and housemaid alike to find and refind their rooms in a confusingly planned house.

But if the names follow whimsy as often as fact, historians have followed the housemaid's footsteps from Preston to Meldrum Tower. Thus Robert W Billings, writing in 1852, before the adoption of this nomenclature, correctly surmised, as it turned out, that 'though the ornamental portions are not very old, they have been raised on work in the common Scottish square form of great antiquity' and proposed a fourteenth-century origin for the Castle. Macgibbon and Ross, however, in 1887, by which date the tower names had been current for a generation, propose that the 'Preston Tower is the earliest portion of the building, having been begun by Sir Henry Preston about the year 1400', and continue: '. . . at the south-west corner is the Meldrum Tower, so called after the next proprietors of Fyvie. They erected this part, and probably the whole range of the south front between this and the Preston Tower'. Macgibbon and Ross add that 'of the early castle of Fyvie, where Edward I stayed in his northern invasions in 1296 and subsequent years, nothing now remains'. This interpretation of the building's history remained current until 1938, when Dr Douglas Simpson, coupling a detailed inspection of the building – one cannot help thinking that the Macgibbon and Ross account is based largely on secondary sources, not least the illustrated sale catalogue of 1885 – with the considerable advantage of access to the Charter Room, denied both before and since to the historians, put forward the hypothesis that the entire lower part of the Castle was of late fourteenth-century date, the work of either John, Earl of Carrick or of Sir James Lindsay.

Simpson's reconstruction of the building's original fourteenth-century plan supposed 'a great frontal range, provided with square flanking towers and pierced about midway by the entrance passage, to the westward of which, at first floor level was the great hall. Behind this frontal range, the castle no doubt tailed off into "laigh biggings" enclosed by a curtain wall'. Simpson also points out the early addition of a square gatehouse block, applied to the centre of the curtain wall, between the Meldrum and Preston Towers and embedded in the present Seton Tower.

In 1962, Simpson was able to test his hypothesis when the harling (roughcast), which covered the Castle, was progressively stripped off and a new coat applied. Simpson now recorded what was uncovered in a series of notes supplemented by photographs. His drawings are now mislaid. The evidence uncovered in this re-harling operation confirmed, and amplified much of his 1938 hypothesis, that in the lower part of the main house front, a substantial medieval castle remains largely intact. It was represented by the lower eighteen feet of the Preston Tower, the lower twenty-five feet of the curtain wall between Preston and Seton Towers, complete to a wall head of embrasures and merlons 'fossilised' in the later heightened south front. Between the Seton Tower and the Meldrum Tower, the early curtain wall was discernible up to a height level with the third floor window lintels (but with no 'fossil' embrasures) whilst the Meldrum Tower contained early work (with one 'fossil' embrasure) at a height of fifteen feet. Removal of the harling from the west face of the west range, exposed masonry of early character to the height of about eighteen feet.

Simpson died in 1968 and his considered conclusions do not survive but he notes that the early walling, composed of field gatherings and split boulders 'could easily be of the thirteenth century'.

The removal of the harling also allowed Simpson to develop further his hypothetical evolution of the central gatehouse block, the Seton Tower. In 1938 he had proposed that the projecting drum towers of the Seton Tower, which clasp his proposed secondary square gatehouse block, were otherwise entirely of late sixteenth-century date. Stripped bare, however, it was clear that these too had been finished to the height of thirty-five feet from the ground with an embattled parapet. Moreover, as originally constructed, their outer faces had been, not straight-sided as at present, but curved inwards to form straight-sided rectangular recesses, oversailed at the upper levels by wide arches. He also noted that the outer west wall of the west wing had been heightened from eighteen to twenty-seven feet, below the uniform red sandstone coursing, which characterises Seton's work of the turn of the sixteenth century.

Whatever its date we must therefore imagine that the Castle at

Fyvie, during the period of Meldrum occupation, had an almost comical resemblance to a child's toy fort.

In severe financial difficulties, George Meldrum was obliged to dispose of Fyvie to Alexander Seton, President of the College of Justice, a deed of sasine being granted by the King under the Great Seal on 20 July 1596.

Sir Alexander Seton was born about 1555, the fourth son of George, 5th Lord Seton, one of Mary, Queen of Scots' most loyal and consistent supporters (fig 1). Intended for the church, he was sent to Rome to study at the College of Jesuits, having already been granted the Priory of Pluscardine in 1565 at the age of ten. He was deprived of this on the fall of Queen Mary, but after the Regent Morton's execution in 1581, the priory was restored to him. Seton became a Privy Councillor in 1585; in 1586 he became an Extraordinary Lord of Session, taking his seat as Prior of Pluscardine. Later in the same year, he was created Baron Urquhart. In 1593 he was appointed Lord President of the Court of Session, one of the principal political advisers to the King, James VI. It was at this point in his rapid rise to political influence that he purchased the estate of Fyvie.

In 1597−8, Seton was made Lord Fyvie, and shortly afterwards he was entrusted with guardianship of the King's second son, Prince

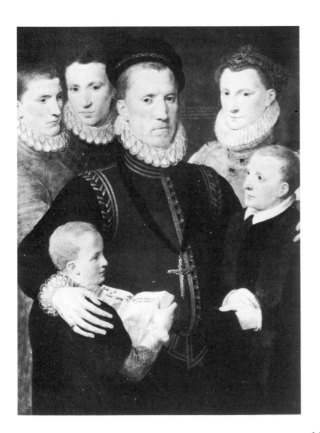

Fig 1

George, 5th Lord Seton and his Family painted by Frans Pourbus the elder in 1572. Alexander Seton, later Lord Fyvie, to whom we owe the transformation of the medieval castle into the present house, is shown on the right of the painting aged fourteen.

National Galleries of Scotland.

Charles, later Charles I. Still with Prince Charles in his care, he was named Chancellor of Scotland in 1604, the King having succeeded to the English throne, and was created Earl of Dunfermline. He died at Pinkie House, Musselburgh, eighteen years later.

Seton was described, shortly after his death, as 'a great humanist in prose and in verse, Greek and Latin, and well versed in the mathematics and great skill in architecture'. Whether he was his own architect at Fyvie is not known, but on the basis of its dissimilarity with Pinkie, which he greatly extended after 1613, it may be assumed that he had different professional help at each house. John Dunbar has tentatively suggested that his architect at Pinkie may have been William Wallace, and John Gifford, on the evidence of Seton's epitaph to William Schaw, at Dunfermline Abbey, has suggested that Schaw may have been the architect at Fyvie.

Little, beyond the two epitaphs of Schaw's monument, is known of either the man or his work, and nothing known to be by him survives for comparison with Fyvie. The epitaphs are instructive however and run, in translation, as follows:

> Beneath this lowly pile of stones lies a man illustrious for his rare experience, his admirable rectitude, his unmatched integrity of life, and his consummate qualities, William Schaw, the King's Master of Works, Master of the Ceremonies and Chamberlain to the Queen. He died 18 April 1602, having sojourned amongst men for two and fifty years. In his eagerness to improve his mind he travelled through France and many other kingdoms. Accomplished in every liberal art, he excelled in architecture. Princes in particular esteemed him for his conspicuous gifts. Alike in his professional work and affairs he was not merely tireless and indomitable but consistently earnest and upright. His innate capacity to service and for laying others under an obligation won for him the warm affection of every good man who knew him. Now he dwells in Heaven for ever. Queen Anne ordered a monument to be set up to the memory of a most admirable and most upright man lest the recollection of his high character, which deserves to be honoured for all time, should fade as his body crumbles into dust.

The second epitaph runs: 'Live in Heaven and Live Forever, thou best of men. To thee this life was toil, death was deep repose. In honour of his true hearted friend, William Schaw. Alexander Seton, Earl of Dunfermline.'

Seton's, and perhaps Schaw's work, at Fyvie must have begun almost immediately; dormer-pediments dated 1598 and 1599, recut, and not *in situ* but now on the east front of the west wing, testify to the rapidity of the transformation of the medieval castle. Externally this involved the complete rebuilding, on a narrower plan, of the whole of the south range between the Preston and Meldrum Towers, behind and above the early curtain wall and its attached gatehouse.

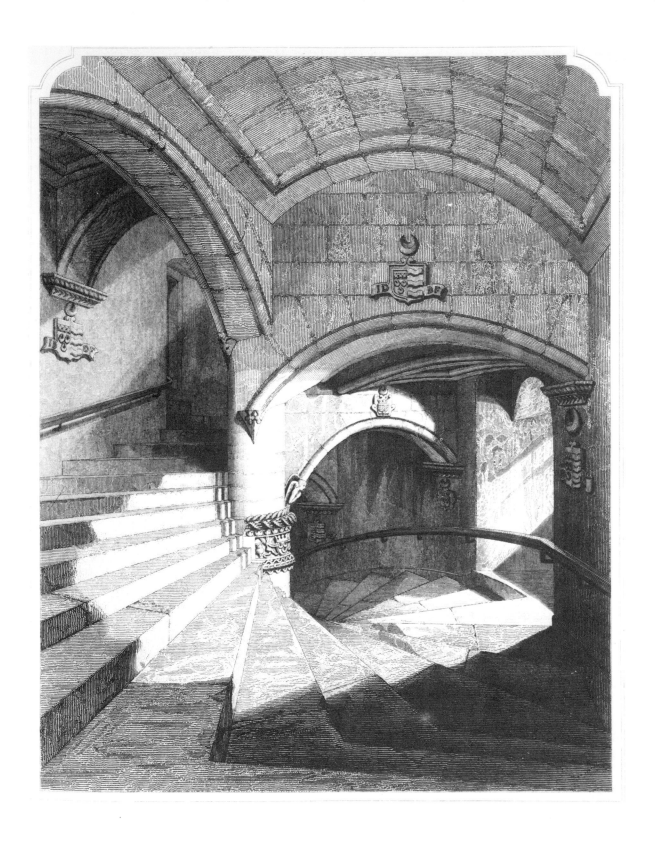

Seton's new work was all of red sandstone, under a unifying coat of harl, in contrast to the field-gatherings and boulders of the early work. His new south range was four storeys high across the front, topped at the centre and at the end with an icing of bartizans and carved dormer-heads. At the centre he bridged the drum towers with a great gabled oversailing arch.

The west wing was also reconstructed behind the old curtain wall and raised to four storeys, though this originally had a plain wall-head, without dormers.

Though the components of Seton's work are straightforward enough – richly carved dormer pediments pushing through the wallhead, and flanked by corbelled angled bartizans – the great symmetrical palace front is without precedent in the canon of Scottish tower houses.

Inside, Seton's work was equally remarkable. Entered at the north-east corner, a small lobby gives immediately into a vast turnpike stair (fig 2), paralleled in Scotland only in miniature, at Noltland. With a radius of ten feet about a central newel which is carved in a belt of ornament with Seton's arms, the stair rises not only to the Great Hall but continues to the second floor. This is a spectacular virtuoso work which must make one regret that nothing has survived intact of the rest of his interior; particularly regrettable is the loss of the long galleries, which William Adam's later survey shows were in the second and third floors of the south front (fig 3).

Of the interior decoration and finishes of the Seton period, only fragments survive: the long oak panel carved with the inscription 'Alexander Seton Lord Fyvie – Dame Gressel Leslie Lady Fyvie 1603', now set in the wall at the head of the great stair, is evidently not *in situ*, and it is tempting to suppose that this was originally set in panelling. Similarly, it is pleasant to think that some of the panelling of the Charter Room, with its Seton crescents and Hamilton cinque-foils, may be made up of pieces from elsewhere in the house. To these fragments might be added the two doors, at the head of the great stair, both bearing Seton crescents and both probably not *in situ* and a piece of armorial stained glass found in a drawer in the 1880s and bearing Seton's arms with the date 1599. A further hint is provided by a late seventeenth-century plasterer's contract which refers to the 'painted chamber'. It is at least possible that this refers

Fig 2

The Great Stair at Fyvie Castle. An engraving after a drawing by R W Billings for his *Baronial and Ecclesiastical Antiquities* 1844-1852. The stair was built for Alexander Seton around 1600. It was decorated by William Gordon in about 1820.

Photograph courtesy of the Royal Commission on the Ancient and Historical Monuments of Scotland.

to a Seton room, comparable in character to the painted timber ceiling decoration of the long gallery at Pinkie.

It is with the contract between the Edinburgh plasterer Robert Whyte and James, 5th Earl of Dunfermline, that the interior of Fyvie becomes readily recognisable. From this contract it is clear that Whyte's work is part of a major updating of the original Seton rooms to form a baroque state apartment. The contract, dated 9 August 1683, and signed at Fyvie, describes the work as follows: '. . . the said Robert Whyte oblidges him to plaister the Great Hall of Fyvie and dyning roume within the same, togither with the great roume above the said dyning roume above the said hall commonly called My Ladies' Chamber, and closet within the samen with handsome architave freis and cornish. Togither with a painted chamber, Bed chamber, Lady Ann Erskine's chamber, Middle chamber, Wardrob chamber, and the two laigh gallery chambers. Togither the haile closet and studies belonging to each of the said chambers with handsome plain cornish work. And that betwixt the date hereof and the last day of Junii nixt to come. And upon the other part the sd. noble Earle binds and oblidges him to furnish materials for the sd. work.'

The Great Hall, with Whyte's ceiling, survives today as the Morning Room. The dining room is presumably the square room beyond it, now the Raeburn Room or small drawing room, though no trace of Whyte's work survives there. Evidently also Whyte's work is the ceiling of the Oak Room at the head of the great stair – a room which seems to be a late seventeenth-century insertion and occupies part of the landing. Not decorated by Whyte, but otherwise the only other late seventeenth-century room in the Castle is the third floor 'panelled room' at the south end of the west range which also retains its bolection-moulded chimney-piece. What survives of Whyte's work is not particularly sophisticated, despite its charm, and does not bear comparison with the best of baroque plaster work in Scotland, for instance the Houlbert and Dunsterfield plaster work of the 1670s at Holyrood and Thirlestane.

The Setons' connection with Fyvie ended in 1690 when, having sided with James VII and II, Lord Dunfermline was forced to flee to France after the Battle of Killiecrankie. The estate was forfeit to the Crown. Despite King William's extraordinarily incompetent attempt of 1695 to give the same estate both to Sir Thomas Livingston and to James, 4th Earl of Linlithgow, the Castle remained Crown property until 1733, when it was purchased by William, 2nd Earl of Aberdeen, with the intention of settling the estate on the children of his third marriage, of 1729, to Lady Ann Gordon, daughter of the Duke of Gordon. At this time Lord Aberdeen, with his architect William Adam, was already engaged in rebuilding his own tower house at Kellie, now Haddo, a few miles to the east of Fyvie, in William

14

Adam's best attempt at the extremely fashionable Palladian style. Haddo was under construction from 1732 to 1735, and the Earl with his new Countess, took up residence at Fyvie, where he was, not surprisingly given his Palladian predilections, dissatisfied with what he found. Two sets of drawings for Fyvie, almost certainly by William Adam, survive from this period. They consist of the survey – two sheets of which are reproduced by Simpson in his 1938 article – and a set of proposals, for which Simpson's passing descriptions must suffice until access to the Charter Room is allowed. The survey is, as Simpson realised, crucial for the understanding of the earlier

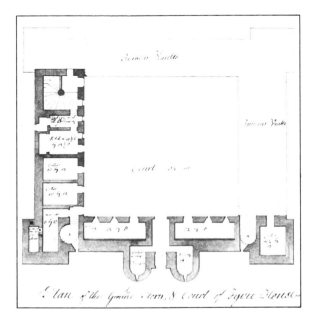

Fig 3

Survey Plan of the ground floor of Fyvie Castle drawn by William Adam in about 1735. This shows the Castle before the late eighteenth-century rebuilding of the south range and the Gordon Tower.

Photograph courtesy of the Royal Commission on the Ancient and Historical Monuments of Scotland.

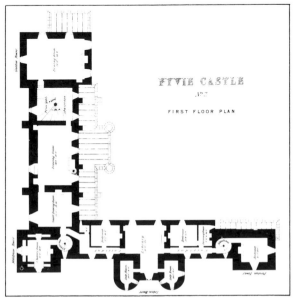

Fig 4

Plan of the first floor of Fyvie Castle in 1885 showing the additions of General William Gordon and his son William.

Photograph courtesy of the Royal Commission on the Ancient and Historical Monuments of Scotland.

history of Fyvie (fig 3). It shows that even as late as the 1730s, the castle was quadrangular in form, the north and east ranges, of single storey height, being described as ruinous vaults. In the absence of documentary or archaeological evidence, it is impossible to be sure whether these ranges represent the courtyard ranges of the thirteenth/fourteenth-century castle, or the service quarters of Seton's 1600 rebuilding. William Adam probably proposed fairly extensive alterations but Simpson's description of his drawings is tantalisingly brief – he notes only that one plan, 'entitled ''a design of the principal floor of Fyvie House'', shows that it was proposed to throw the whole of the first floor of the gatehouse (Seton Tower) into one large room, absorbing everything except the bows of the tower.'

Apart from a basket-arched chimney-piece in the Charter Room, nothing survives internally or externally of this period, and it may be doubted whether any major work was in fact carried out.

The Earl of Aberdeen died in 1745 and Haddo passed to his eldest son. The young widow continued to live at Fyvie with her children, the eldest of whom, William Gordon, became, at the age of nine, the possessor of the Castle. Clearly William Gordon was not then of an age to initiate any large-scale building operations, and it was not until 1777, ten years after his return from Rome, that he seems to have carried out any work. An armorial panel, with this date and with his initials, now over the north courtyard door of Preston Tower, was, until the future Lord Leith's alterations in 1899, set over the arched central opening on the north wall of the south block. This wall is eighteenth-century, the south range being deepened in plan and reduced in height from four to three floors. The assumption that the 1777 datestone refers to this work is complicated by the existence of a drawing, in an unidentified hand, from the office of Robert and James Adam, in the Soane Museum (fig 5). This pen and wash view from the south-west clearly relates to a pair of equally sketchy but apparently accurate views of Cluny Castle, Aberdeenshire, also in the Adam collection. These drawings, showing the existing building from two viewpoints, relate to schemes of about 1789 to 1793, for the enlargement of Cluny; it is likely that a similar date attaches to the Fyvie view. The Adam office drawing, whilst inaccurate in the details of the upper works of the Seton Tower – the angle bartizans are stretched in height – is apparently accurate in showing the original full height of the Seton south range, and can be shown to be accurate in its representation of the west wing dominated by the great chimney flue of the kitchen. Not the least puzzling feature of this drawing is that it shows the roofs of the Meldrum and Preston Towers' bartizans removed.

Some support for a view that the Adam office drawing is intended as the representation of the existing building, and datable to about 1789, rather than a proposal for alterations, is to be found in *The*

Statistical Account of Scotland of 1793, which concludes the description of Fyvie with the comment that 'when the addition, which is at present making to the house is finished, it will be one of the largest and most commodious houses in the country'.

There is no other evidence of Adam's involvement in the alterations of the Castle and, until the Charter Room can be properly searched, the architect and the date for the alteration to the south range and the addition of the Gordon Tower must remain a matter of conjecture. The Gordon Tower is William Gordon's major contribution to the development of the Castle, for dramatic though the reduction in height of the south range was in its effect upon the profile of the main front, the gain was largely the provision of corridors to the bedrooms (fig 4). The Gordon Tower is remarkable not only for what it provides internally, a big dining room at the first floor and a new kitchen below, but for its external design. Attached to the north end of the west wing, it closely matches the Meldrum and Preston Towers in detail, and when built, betrayed its date only in the hard edges of the exposed angle margins and the mechanical carving of the corbelled bartizans. The angle margins have since been harled over. This determined and largely successful attempt to repeat the old work is, even for a date in the 1790s, an astonishingly early essay in the Baronial Revival.

General William Gordon was succeeded by his son, William Gordon, who, in a statement attached to his will of 1844, describes the Castle at his succession in 1816, and the improvements for which he was responsible:

The Castle of Fyvie in the year 1816 was, with the exception of a few apartments, in a state of great delapidation, the farm offices were nearly ruinous, and there was a great deficiency of the necessary accommodation for a resident Proprietor. The Castle was completely renovated, a new vestibule erected, and outdoor additions of various descriptions made, including among others a larder, ice house, scullery, washing and brew house, poultry house, dog kennel, porters' lodges, butler's house, bridges across the Ythan, tool and other houses in the garden, greenhouse, coach house and stables, thrashing mill house and grain lofts, etc., etc., and water was introduced into the Castle from Springs brought a great distance.

The low ground around the Castle was one continuous swamp, and to the extent of at least 70 acres, totally unproductive. To remedy this the course of the river was changed and a new course also formed for the Skeugh Burn and drainage to a great extent carried on; by which operations 70 acres of the finest land in the Parish have been added to the home farm.

As a specimen of the extent of these operations, it may be noted that a new channel for the Ythan was made above and below, and

through the Castle grounds to an extent little short of three miles.

Besides the ornamental wood within the park, I have planted upwards of 200 acres of unproductive land and enclosed it with stone dykes around the domain; planted and protected about three miles of hedging, and made within the grounds about the same extent of roads and drives. The garden has been laid out and enlarged and has been filled with the most expensive flowers, evergreens and fruit trees; and a large sum has been expended in bringing a steady and abundant supply of water to the lakes within the grounds.

From documents in my possession it appears that the outlay made by me for the various objects above detailed exceeds the sum of £40,000 all of which my successor will reap the benefit in the great increase of his rent-roll, and in the increased amenity, comfort, and beauty of the place.

William Gordon's only external addition to the Castle was the hall or vestibule – a single storey block, advanced at the centre, with pretty pointed roofed angle towers, set against the east wall of the west range. Inside, it must have been a wonderfully flashy Regency interior, its sanded walls painted to look like stone and with an oak-grained gothic ceiling, it was lifted into fantasy by the mirrors set into arcading at either end. 'One may question the goodness of the taste which has inlaid both ends of the hall with looking glasses, and multiplying its reflection, give it the appearance of almost indefinite length', wrote Billings, flatly, in 1852. Most of the mirrors survive, but the removal of those at the north end of the vestibule, to form an entrance to the billiard room, has spoilt the effect. The vestibule gives on to Seton's great stair, the walls of which were now plastered and painted in imitation stone, and set with plaster panels of the Seton and Gordon Arms.

At the top of the stair a dormer-finial has been re-used as a termination to the newel and this skewers another oak-grained plaster, gothic ceiling, set with armorials. The same ceiling pattern is repeated along the second floor bedroom corridor in the west wing. In his father's dining room, he was presumably responsible for the decorative painting of the ceiling, 'relieved with Shields at the corners, bearing coats of Arms and with light French ornaments', as described in the 1885 sale catalogue.

The architect of this work is, as usual, unknown, although the characteristically Aberdeen joiner-work of the small drawing room, or Raeburn Room – round panels at the end of the shutters, fat reeded window surrounds and the Greek key frieze of the dado – suggests that the architect was from Aberdeen.

William Gordon died, unmarried, in 1847, and he was succeeded by a cousin Charles Gordon, who since he was then seventy-one, transferred the estate to his eldest son Cosmo. Captain Cosmo

Gordon was responsible for the refitting of the Dunfermline and Gordon bedrooms, this last 'made hideous by being hung with Gordon tartan' according to Mrs Henry Ross in 1884. During his time too the Charter Room was panelled as a smoking room and similar panelling composed of antique fragments was used to line the oak room at the head of the stairs. Captain Cosmo Gordon's chief interest is not architectural, however, but lies in his attempt to disinherit his cousin, Sir Maurice Gordon. According to Mrs Stirling's *Fyvie Castle*, 'Sir Maurice was well-known to be a man of wild life, who was said to be heavily in debt. Captain Gordon was convinced that if his cousin, Sir Maurice, came into the property he would squander it rapidly, and therefore he determined to cut him out of the entail. He consulted his solicitor, and the papers were drawn up in due order, merely awaiting his signature. He therefore rode into Aberdeen with them in his pocket, intending to sign them in the presence of his banker and solicitor; but on the threshold of the bank he fell dead, with the papers unsigned!'

Sir Maurice, thus inheriting the property, converted one of the Seton drum tower rooms into an oratory, and made a fruitless attempt to break into the mysterious walled-up chamber at the ground floor of the Meldrum Tower, perhaps in the hope of finding something valuable, for within a year the house, with its estate, was up for sale (fig 6).

In 1889, house and estate were bought by Alexander Leith. His mother was a Forbes of Blackford, a small estate a few miles from Fyvie, and Alexander Forbes-Leith could, somewhat indirectly, trace his descent from Sir Henry Preston, the fifteenth-century owner of Fyvie Castle. Mrs Stirling, in her hagiographical account of the Leiths, tells the story of the six-year-old Alexander, walking from Blackford to Fyvie and announcing to the servant who answered the door that he had come to see Fyvie, since he meant to have it one day.

The heir to Blackford could not have afforded to have it one day had he not married money in the pretty shape of Miss Louise January, and gone on to make a good deal more in the American steel industry. It was this American money that was now channelled into Fyvie. Mrs Stirling describes the state of the castle: 'Thus, while nothing could rob the place of the glamour of its great antiquity, to a critical eye it presented superficially much which was bare and unlovely. The furnishing of the interior was dreary and of the worst period, incongruous against such background; antique and modern were intermingled with a lack of discrimination characteristic of that date'. This is the authentic voice of Alexander Forbes-Leith, but even the faithful Mrs Stirling sounds a slight note of criticism when she describes his remedy: 'Within the Castle the same evidence of a master-mind was displayed. The new Laird eliminated with a relentless and almost too-drastic completeness all that he held to be ugly or

unworthy of such a setting'. Returning to her usual, gushing style, she continues: 'Meanwhile he introduced throughout the building plenishments dignified in their rich quietude, (what can these have been?), antique and graceful furniture, fine tapestries, armour so interesting that a whole book descriptive of it has been written, and pictures whose beauty is for all time – Gainsboroughs, Romneys, Opies and some of the finest portraits ever executed by Raeburn.'

In 1890, the year after he had bought the estate, Alexander Forbes-Leith employed John Bryce to make an addition to the Castle. John Bryce was not an obvious choice. He had been in partnership with his uncle, David Bryce, from 1873 until the latter's death in 1876 but had been unable to sustain what had been the most successful country house practice in Victorian Scotland. It was not incompetence nor lack of originality that let him down but perhaps the muscular, full-blooded Baronial style of the 1850s to the 1870s had had its day and John Bryce was unwilling or unable to change, even when freed from the dominating influence of his uncle.

John Bryce would have been familiar with Fyvie from the engraved views of Billings' *Baronial and Ecclesiastical Antiquities*, which was to the Baronial Revival what Stewart and Revett had been to the Greek Revival – a quarry whose steely plates were translated effortlessly into one mansion after another, at once crib sheet and holy writ (fig 2). Thus the characteristic arched Seton Tower at Fyvie, recurs in David Bryce's Craigends of 1857 (fig 9) and in his re-baronialising of the savagely Georgianised Blair Castle in 1869. Huge exhibition watercolours of both houses hung in the Bryce office.

At least two schemes were provided by John Bryce – drawings for an unexecuted proposal are known to be in the Charter Room (fig 7). The scheme on which Forbes-Leith settled, extended the Gordon Tower westwards in a wing whose prominent oriel windows, decorated with the initials of Forbes-Leith and his wife, and the date 1890, derived from Huntly Castle. This was an ingenious precedent to follow – Huntly is not only quite close to Fyvie but the upper

Fig 5

Fyvie Castle from the South-West by an unknown draftsman in the office of Robert and James Adam probably *c* 1789. This appears to show the south range standing to its full four storey height between the towers.

Photograph of a drawing in the Sir John Soane Museum, London: Adam collection no 26, vol 2.

Photograph courtesy of the Royal Commission on the Ancient and Historical Monuments of Scotland.

Fig 6

Fyvie Castle from the South-West. Photograph by Valentine and Co: this shows the Castle just before it was acquired by the Forbes-Leiths in 1889.

Photograph courtesy of the Royal Commission on the Ancient and Historical Monuments of Scotland.

Fig 7

Fyvie Castle from the South-West. A perspective view drawn in John Bryce's office in 1890. It shows the proposed addition of the Leith Tower.

Photograph courtesy of the Royal Commission on the Ancient and Historical Monuments of Scotland.

Fig 5

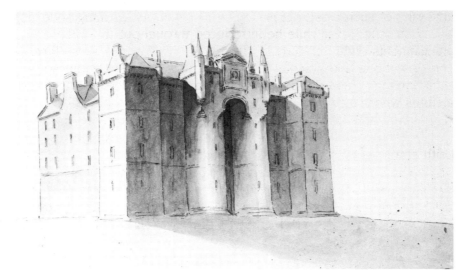

Fig 6

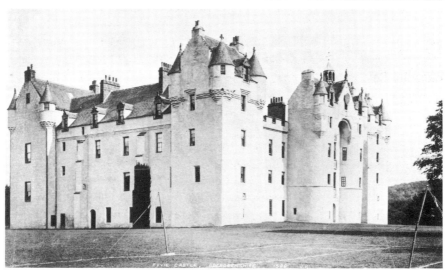

Fig 7

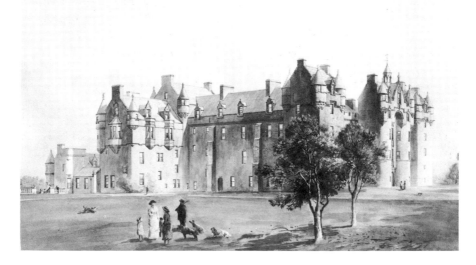

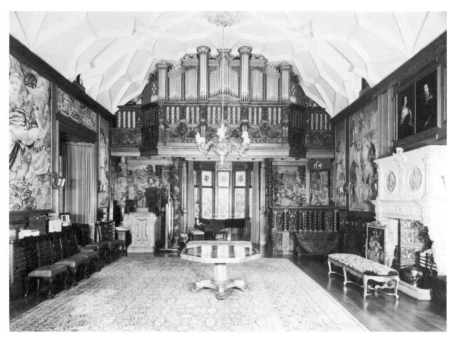

Fig 8

Music Room, Fyvie Castle. The room is on the top
floor of the Leith Tower, designed by John Bryce in
1890. The special symphony self-playing pipe-organ
was bought in London and installed for Lord Leith in
1906.

Photograph courtesy of the Royal Commission on the Ancient and
Historical Monuments of Scotland.

works with their great oriel windows banded with inscriptions naming
George Gordon, 1st Marquis of Huntly and Henrietta Stewart his
wife, are virtually contemporary with Seton's work at Fyvie.

The real advantage that Huntly offered, and this must have been
the determinant, is that it allowed John Bryce to make his grandest
apartment at second floor. He doubled the size of the second floor
morning room, in General William Gordon's Tower, to provide a
drawing room at one end, and a big plaster vaulted music room at
the other (fig 8). This is lined with tapestries and fitted with an
enormous organ, supplied by Herbert Marshall of London in 1906,
at a cost of £14,000, its 'special carved oak screen', costing an addi-
tional £55, carried on a wonderfully crazy sub-structure, cobbled out
of more than one Dutch oak church screen. In the drawing room a
ravishingly pretty neo-classical chimneypiece was inserted; Ian Gow
points out that a design for a near identical chimneypiece was pro-
vided for Lord Dundas in 1773 by James Byres of Tonley, the
Aberdeenshire architect and antiquary, resident in Rome, whom
General William Gordon would certainly have met in 1765. Unfortun-

22

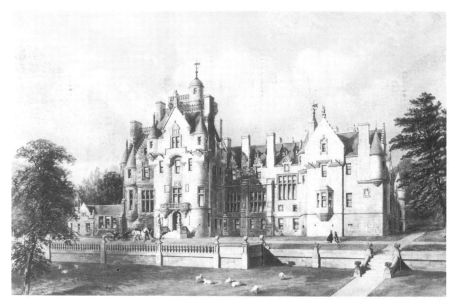

Fig 9

Craigends House, Renfrewshire. Designed in 1857
by David Bryce, uncle of John Bryce, who used Fyvie's
Seton Tower for its principal feature.

Photograph courtesy of the Royal Commission on the Ancient and
Historical Monuments of Scotland.

ately this chimneypiece cannot be identified in the adequate but
bald descriptions of the 1885 sale catalogue, and the attractive sup-
position that this, like the Batoni portrait dates from General Gordon's
Grand Tour, must be surrendered in favour of the guess that Marshall
Mackenzie, now Forbes-Leith's architect, brought the chimneypiece
from Tonley, Byres's house, which he was remodelling in a Baronial
style in the 1890s.

Gordon's dining room, on the floor below (fig 16), was panelled,
with a portrait of Louise January set above the fireplace, whilst a
new strap-work ceiling, with pendant bosses and armorials, and
dated 1890, replaced the 'light French ornaments' of the 1830s. The
next year the kitchen on the ground floor of the Gordon Tower
became a billiard room, the stone fireplace, recording the change in
an inscription, being supplied, with the grate in the library, by Mark
Feetham & Co of London in 1900, and fitted by them in the
following year.

The hall fireplace is also by Feetham; directly opposite the main
entrance door, in the enlarged 1830s vestibule, it is the first thing

the visitor sees, and is designed to establish Forbes-Leith's credentials. Above the fireplace is a bas-relief showing the Battle of Otterburn, during which Sir Henry Preston, Forbes-Leith's forebear, so distinguished himself that he was granted the estate and Castle of Fyvie. In case the visitor should miss the point, the dates 1390 and 1890 are set above the panel. The same dates, with Forbes-Leith's arms and those of the successive families who owned the castle in the intervening 500 years, are set out around and below the great clock, with its flanking bartizans, which was built in 1899, to Dr Marshall Mackenzie's design, at the centre of the later eighteenth-century north front of the south range. The roof of the south range was heightened at the same time to provide servants' accommodation, and the battlements remodelled.

Below the great clock, is an oriel window inserted to light the library, which was fitted out in a lavish mid eighteenth-century manner beneath its 'Jacobethan' ceiling; at the same time the panelling of the Great Hall, now morning room, was remade, with a new fireplace in seventeenth-century style formed at the south end. The small drawing room next door, already largely late-Georgian in character, was apparently heightened in effect with the remodelling of the ceiling plasterwork and possibly with the addition of two splendid brass inlaid mahogany doors, all to house Forbes-Leith's unrivalled collection of Raeburn portraits.

Finally, as part of the series of minor work, carried out between 1913 and 1920, Lord Leith as he now was, rebuilt the bell turret on the top of the Seton Tower. Since Lord Leith's death in 1925, little has changed – the bell turret has been dismantled and the small drawing room redecorated; the laird's father tinctured the armorials of the dining room ceiling and allowed Sir Andrew to choose the cowboy and Indian wallpaper of the nursery from Esslemont and Mackintosh in Aberdeen.

No doubt the National Trust for Scotland will rebuild the bellcote. I hope they will spare the cowboys and Indians.

Richard Emerson

THE COLLECTION OF PAINTINGS AT FYVIE CASTLE

Of all the many paintings at Fyvie Castle, Pompeo Batoni's magnificent full-length portrait of Colonel William Gordon is the most famous (no 16). A masterpiece, it represents one of the most notable owners of Fyvie who did much to rebuild and enhance his property. William Gordon's architectural activities have been described by Richard Emerson in his essay. Suffice it to say the Gordons must have had much to do when they acquired the estate from the Government.

The Seton family had been the previous owners but their commitment to King James VII, regnant and in exile, caused them to forfeit the Castle. If the Setons had a collection of paintings at Fyvie in the seventeenth century then it must have been dispersed. For almost fifty years the forfeited estate belonged to the Government until, in 1733, William Gordon, 2nd Earl of Aberdeen, Laird of the neighbouring Haddo estate acquired Fyvie. He bought it to settle on his children by his third wife, Lady Anne Gordon, the youngest daughter of his friend and contemporary Alexander, Duke of Gordon. It is said that the Duke insisted on the Earl's purchase as part of the marriage bargain for there was already by an earlier marriage an heir to Haddo and the earldom of Aberdeen.

Lady Anne Gordon and her elderly husband had a large family. Their eldest child, William, is the subject of Batoni's portrait, a painting which must have been one of the first to be acquired for the Castle since the great Seton clearance at the end of the previous century. It is the Batoni which is the foundation stone of the present collection.

William Gordon, born in 1736, succeeded his father as laird of Fyvie at the age of nine. He studied at the University of Glasgow and at twenty became a cornet in the 11th Dragoons. He soon saw action abroad, taking part in the war to drive the French out of southeast India. By the time he made his grand tour to France and Italy in the middle years of the 1760s William Gordon was a Lieutenant-Colonel in the 105th Regiment of Foot. Pompeo Batoni was the

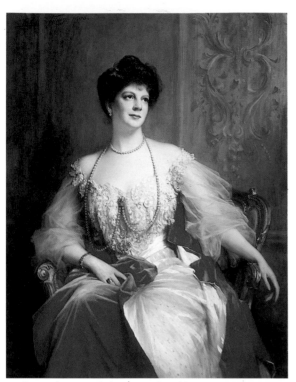

Lady Forbes-Leith by *Sir Luke Fildes* (no 66)

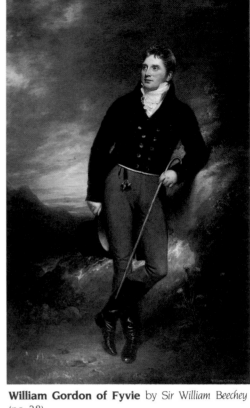

William Gordon of Fyvie by *Sir William Beechey* (no 28)

The capture of the Royal Prince by *Hendrick van Minderhout* (no 9)

John Stirling of Kippendavie and his daughter, Jean by *Sir Henry Raeburn* (no 41)

The Sound of many waters by *Sir John Millais* (no 60)

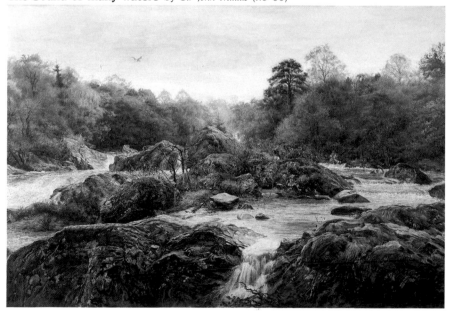

leading portrait painter in Italy and by far the most popular artist with the rich young British tourists. He was the natural choice for Colonel Gordon, particularly since his first cousin Alexander, Duke of Gordon had recently sat to Batoni and this portrait, another grand full-length, was in Batoni's studio for the Colonel to see when he in turn sat for his portrait. There may have been a deliberate element of competition in William Gordon's commission – a desire to outshine his young cousin and clan chief. Twelve years later they quarrelled acrimoniously about recruitment in the north-east and two rival regiments were formed. That quarrel was serious enough to cause a breach between the two closely-related families.

In Rome, as well as sitting to Batoni, William Gordon was shown the sights of the city by the Abbé Grant, the Glenlivet-born Roman agent of the Scottish Catholic Mission. They were often accompanied by James Boswell. On one occasion all three visited St Peter's as Boswell recorded in his journal: 'April 5 1765. Yesterday morning went with Colonel Gordon to St Peter's, Abbé Grant conductor. Gordon said though a heretic (he was) sure to be damned, was glad to see so many other people going to heaven'. Boswell visited Batoni's studio the same month and watched the artist at work on Gordon's complicated drapery. He met Gordon again in Paris where the Colonel had become friends with another eminent Scotsman, the philosopher David Hume. Horace Walpole records dining with both of them in Paris and made use of Colonel Gordon to carry seeds and peppermint water back to Lady Hervey in England.

William Gordon returned to Britain early in 1766 while Batoni was still finishing his portrait. It was completed later that year and may have been sent straight to Aberdeenshire for installation in the Castle. Whether he bought other paintings for Fyvie is unknown, but it is unlikely. There are no works by contemporary Italian artists favoured by many British visitors to Rome nor are there any Italian city views, also popular with the tourists. After his return from the grand tour William Gordon led a full life as a general, a Member of Parliament and a courtier. His activities as far as Fyvie was concerned were concentrated on rebuilding the ancient Castle and making it a more comfortable and convenient building. The systematic formation of Fyvie's art collection was begun by his son and was the work of another century.

That son, also called William Gordon, inherited in 1816 and one of his first acts was to have his portrait painted. His choice of an artist was interesting and original. Instead of employing Sir Henry Raeburn as almost any other rich Scottish laird would have done he went instead to London, to Sir William Beechey, who produced one of his finest works (no 28).

William Gordon was the first member of the Aberdeenshire gentry to notice and employ the young landscape painter James Giles who,

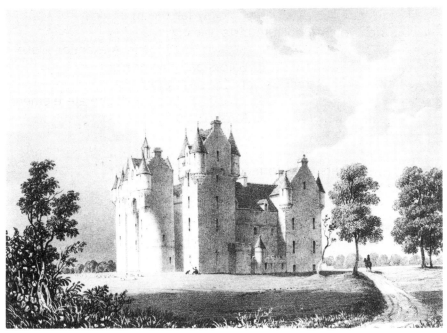

Fig 10

Fyvie Castle from the South-East. Lithograph after
a drawing of 1840 by James Giles. It shows William
Gordon's new entrance and vestibule added after 1816.

Photograph courtesy of the Royal Commission on the Ancient and
Historical Monuments of Scotland.

when Gordon was introduced to him in 1822, was an untrained and
inexperienced young man of twenty-one. Whether Gordon helped
to finance Giles's several years of study in France and Italy is not
known but soon after his return in the mid-1820s Giles was receiving
commissions from William Gordon (fig 10). Scenes on the estate at
Fyvie and on Gordon's other property, Maryculter, were exhibited in
Edinburgh in 1831. Gordon's own portrait by Giles was also exhibited
at the Scottish Academy. Another of Giles's paintings owned by
Gordon was a Virgin and Child with St John. This would have been
a surprising painting to find hanging in a presbyterian house and it
has been suggested that Gordon was a Roman Catholic. There are
accounts of fathers from Blairs College visiting the Castle and in
returning to the Roman church Gordon would merely have been
reverting to the faith of his not too distant forebears. His religion
and concomitant Jacobitism would explain the presence in the Fyvie
collection of such paintings as James Wales's portrait of Charlie
Leslie (no 22) and Wass-dail's *Bonnie Prince Charlie*.

Until Fyvie's early nineteenth-century inventories are discovered it
is impossible to know what pictures apart from those by Giles were
collected by William Gordon. Early Victorian accounts of the Castle
stress the library and the fine collection of old masters and modern

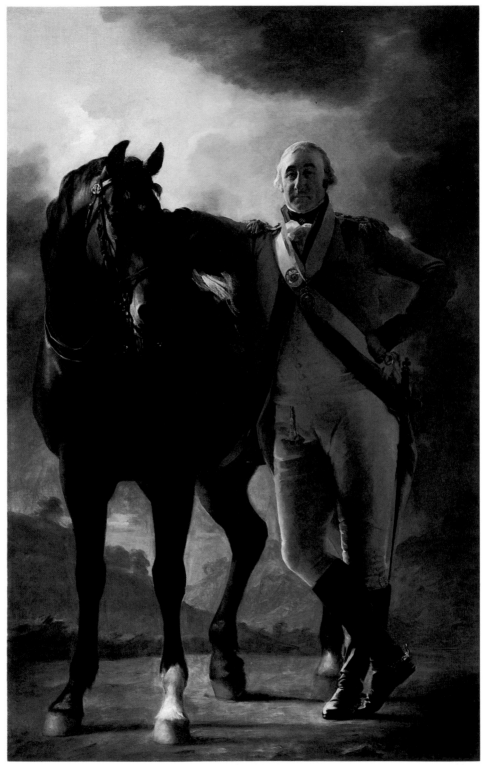

Sir William Maxwell of Calderwood by *Sir Henry Raeburn* (no 39)

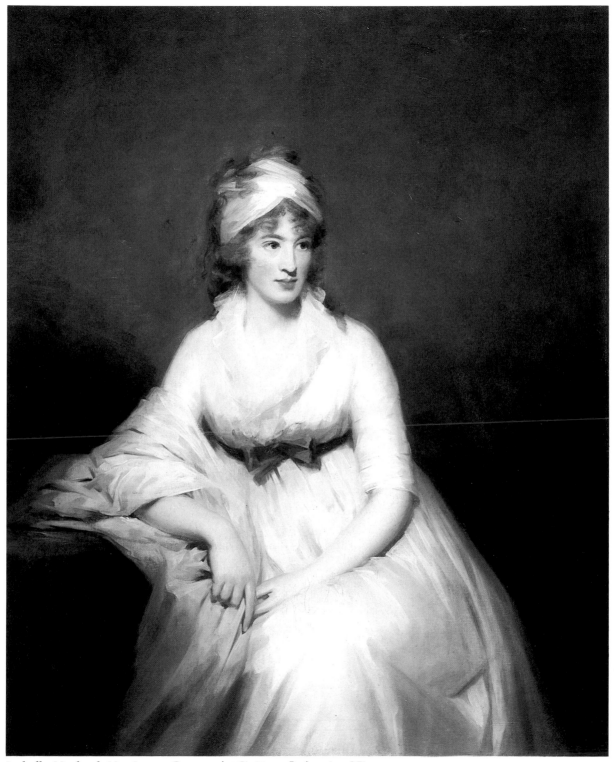

Isabella Macleod, Mrs James Gregory by *Sir Henry Raeburn* (no 37)

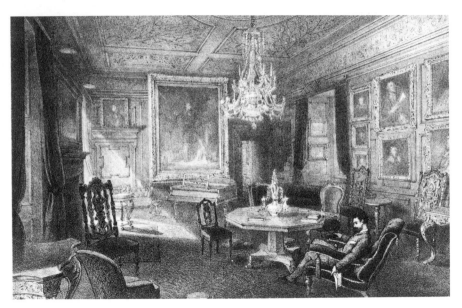

Fig 11

Morning Room, Fyvie Castle. Now the morning room, this view of 1885 shows the original great hall of Seton's castle. When the Gordons lived at Fyvie the room was used as a drawing room.

Photograph courtesy of the Royal Commission on the Ancient and Historical Monuments of Scotland.

paintings. There are a number of pictures like Mignard's *Duchesse de la Vallière* (no 4) which have frames of the early nineteenth-century and which may well have been William Gordon's acquisitions.

As well as decorating the castle interiors with furniture and works of art (fig 11) William Gordon spent lavishly on landscaping the castle grounds; £40,000 was the sum that Gordon himself claimed to have spent. It is likely that in his landscaping activities Gordon was at least assisted by James Giles, for landscape gardening became an important part of his professional work as he became better-known. It was Gordon who introduced him to neighbouring land-owners like Lord Aberdeen, the Prime Minister in the early 1850s, for whom Giles worked extensively at Haddo, both inside and outside the house. Giles's friendship with William Gordon remained firm. He named one of his children William Gordon Giles after his friend and patron and in 1846 presented him with his self-portrait (no 55).

Although not a politician William Gordon played his part in the affairs of the county. He was a founding member of the Spalding Club of Aberdeen, a society established in 1839 for the publication of antiquarian and literary material relating to the counties of the north-east. After William Gordon's death in 1847 his cousin's son and successor at Fyvie, Cosmo Gordon, also became a Spalding Club member, chairing the Annual General Meeting in 1861. Neither

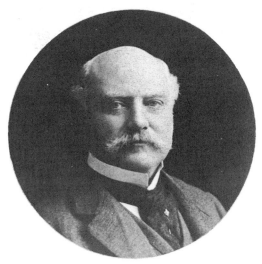

Fig 12

Alexander Forbes-Leith, Lord Leith of Fyvie. A
photograph taken in about 1905.

Cosmo nor his brother Alexander had children and after their
deaths, in short succession, Fyvie was inherited by their cousin, Sir
Maurice Duff-Gordon. He was the last of the Gordons to own the
Castle and with its sale in 1889 a new owner and a new dynasty
arrived at Fyvie in the formidable presence of Alexander J Leith,
newly-elected President of the Illinois Steel Company of the United
States of America.

 Despite his transatlantic connections Alexander Forbes-Leith (fig 12),
as he was known from 1889, had been born quite close to Fyvie, at
Blackford. His father, John James Leith, was a scion of an old
Aberdeenshire family, the Leiths of New Leslie, while his mother was
Margaret Forbes of Blackford. Through her he claimed descent from
Sir Henry Preston who had been granted the lands of Fyvie in
1390–1 by King Robert III. A family legend suggests that Forbes-Leith
had, since childhood, nourished the idea of one day taking posses-
sion of Fyvie.

 As a youth he entered the navy, seeing action in the New Zealand
war. In 1870 when his ship HMS *Zealous* lay docked in San Francisco
he met at a ball a girl from St Louis, Missouri. Louise January was
the daughter of Derrick January, the chief proprietor of the Joliet
Steel Company of Illinois. Alexander Forbes-Leith and Louise January
were married the following year when he was aged twenty-four. He
soon abandoned the navy and joined his father-in-law's company.
Forbes-Leith was a natural businessman and rose rapidly to become
by 1885 the President and principal shareholder of the Joliet Steel
Company.

 At the time of the Fyvie purchase he was involved in one of the
largest business transactions of his career, the foundation of the

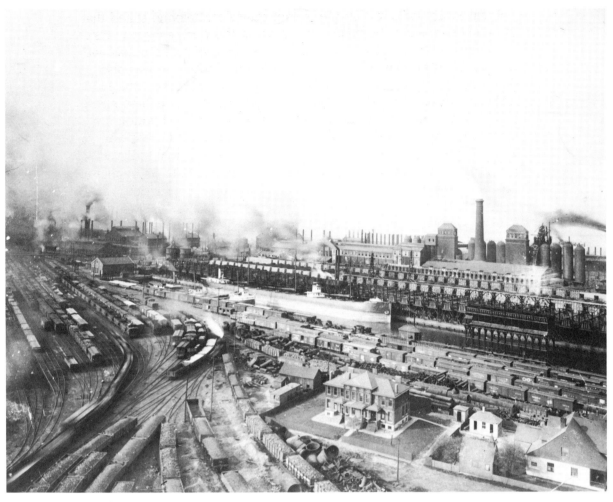

Fig 13

**Illinois Steel Company Works, Calumet Harbor,
Chicago, Illinois.** Alexander Forbes-Leith was President
of Illinois Steel when he bought Fyvie in 1889.

Photograph courtesy of the Chicago Historical Society.

Illinois Steel Company, formed by a merger of the Joliet Steel, the
Union Steel, and the North Chicago Rolling Mill companies. This was
the first large consolidation in the history of the steel industry in the
United States, creating the largest company in the world at that time,
with a workforce of 10,000 men (fig 13). Alexander Forbes-Leith
emerged as President of this powerful new conglomerate and a
very rich man.

Armed with an American fortune Alexander Forbes-Leith was in a
position to be able to seize the opportunity presented by the
unexpected sale of Fyvie. Paying almost a million dollars, the Forbes-
Leiths became only the fifth family to possess the Castle in as
many centuries.

When Fyvie appeared on the market the sale catalogue stated that arrangements might be made 'under which the purchaser may take over the whole furniture, collection of historical pictures, books and other articles at valuation'. This Forbes-Leith did, but he was also ambitious to create his own collection which would be worthy both of Fyvie's history and the Forbes-Leith fortune. He immediately contacted dealers in art and antiquities. For paintings the London firm of Thomas Agnew was both adviser and agent. Over a period of some thirty years they helped create the collection now at Fyvie.

In many ways the collection is typical of its time with its emphasis on British portraits of the late eighteenth century. The period from 1890 to 1930 was the heyday of Gainsborough, Reynolds, Romney, Raeburn and Hoppner, all of whom appealed to Forbes-Leith. Although the artists were British the purchasers were often American and the Fyvie collection fits the pattern formed by many other American collectors particularly from the mid-west states, whence Forbes-Leith's own fortune was derived. Many of his colleagues in the US steel industry were also creating collections, Henry Clay Frick and the Pierpont Morgans being the most notable.

Forbes-Leith's collection, however, has a personal quality which distinguishes it essentially from that of his millionaire art-collecting contemporaries. Imbued as he was by a sense of his family's antiquity and the history of the house in which he now lived Alexander Forbes-Leith set out to buy paintings which were connected with the history of the Castle and with the families from which he himself had sprung. John Burnet's *Trial of Charles I* (no 59) for instance, must have been chosen because of the King's early childhood at Fyvie. Among the portraits of his family's ancestors is the remarkable group of Gregory portraits, the 'Jamesone' (no 2), Romney's *Captain Forbes* (no 24), and Raeburn's portrait of Dr Thomas Reid (no 40).

In this respect Alexander Forbes-Leith was unusual amongst his millionaire art-collecting contemporaries. Not for the Huntingtons of California, the Tafts of Cincinnati or the Burtons and Guinnesses of London were there ready-made ancestors to be had for the asking. Alexander Forbes-Leith's fortune might be recent but he could claim kinship with some of the oldest families of Aberdeenshire; and his collection was there to prove it. Fortunately for Fyvie many of Forbes-Leith's ancestors had been painted by distinguished artists. The Gregory family for instance, ancestors on his mother's side, had been particularly well served. John Scougall's portrait of the astronomer James Gregory is an especially fine example of Scottish seventeenth-century portraiture. The astronomer's grandson Dr John Gregory and his wife inspired Cotes. Their son Professor James Gregory and his wife sat to Raeburn who painted the finest pair of portraits of his career.

By 1890 these portraits had descended to various near relations

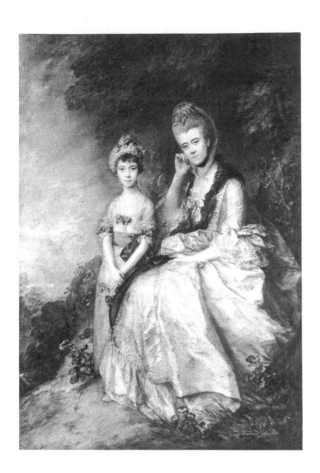

Fig 14

The Countess of Sussex and her Neice by *Thomas Gainsborough*. The painting was owned for less than two years by Alexander Forbes-Leith. It was sold during a period of recession in the United States steel industry.

Photograph courtesy of Michael Tollemache Ltd, London.

Fig 15

Helvoetsluys by J M W *Turner*. Owned briefly by Alexander Forbes-Leith in the mid-1890s.

who seem to have been only too delighted to sell them to their rich connection. The 'Jamesone' group (no 2), the Waller Paton (no 54) and Huggins's *Thracian* (no 58), all came from relations. So too did the great Raeburn portrait of John Stirling of Kippendavie and his daughter (no 41) though in that case he was not buying one of his ancestors but the ancestors of his sister's husband. Forbes-Leith considered these family paintings as a group apart. Whereas he was always prepared to trade the rest of the collection, the family portraits were sacrosanct. Even Agnew's most tempting offer for Raeburn's *Mrs Gregory* at the height of the slump in the United States steel industry was resolutely refused. With the rest of his collection he was quite happy to buy and sell. Indeed he treated Agnew's rather like a firm of stockbrokers, consulting them constantly about his portfolio. 'You have a very valuable property in fine art', wrote Lockett Agnew to his client in October 1896, 'whatever times may be. You have bought the best, and the best will always sell; and if unhappily we should be forced to sell these pictures for you next season, I will unhesitatingly prophesy that looking at the price of stocks at the time you bought these pictures, and the price you paid for your fine art property – what we should realise for you will compare most advantageously with the current price of stocks at the time of realisation'.

The Illinois Steel Company was going through a bad time in 1896. The previous year it had made a profit of $1,233,266 but in 1896 it registered a loss of $704,281. Part of the collection had to be sold and some great masterpieces among them. Gainsborough's *Countess of Sussex and her niece* (fig 14) was the saddest loss to the collection and a work which Forbes-Leith was never able to replace, certainly not with Gainsborough's perfunctory *Major Tennant* (no 14) which was bought in 1902. The only Turner oil Forbes-Leith ever owned, the seascape *Helvoetsluys* (fig 15) was also sold to reduce his large debt with Agnew's. Works by Romney, Raeburn and Wilkie were also handed back to Agnew's and Forbes-Leith had almost to start his collection over again at the beginning of the new century. By then Alexander Forbes-Leith, or Lord Leith of Fyvie as he became in 1905, was domiciled in Britain and had severed his executive role with the Illinois Steel Company and the Federal Steel Company which succeeded it.

The years between 1899 and 1904 were his most active collecting years: another six Raeburns were added to the two Gregory portraits, and he also acquired four Romneys and works by Gainsborough and Lawrence. In 1904 he had the difficult choice of two magnificent full-length Raeburns, *The McNab* or the portrait of Sir William Maxwell of Calderwood (no 39). He chose the latter and *The McNab* was acquired by Sir Hugh Lane and subsequently by John Dewar & Sons. As well as the Raeburns Lord Leith bought many pictures by Scottish

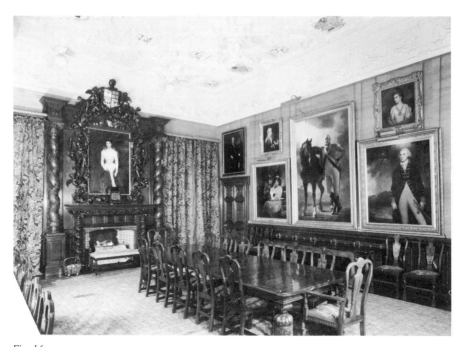

Fig 16

Dining Room, Fyvie Castle. Built by General Gordon
in about 1793 but entirely refitted by John Bryce for
Alexander Forbes-Leith in 1891. The portrait of Louise
January, Mrs Forbes-Leith, is set in the overmantel.

Photograph courtesy of the Royal Commission on the Ancient and
Historical Monuments of Scotland.

artists: Ramsay, Wilkie, Pettie, Chalmers, Farquharson and Sam Bough.
He was buying for three houses, 23 St James Place in London and
Hartwell House, Aylesbury, as well as Fyvie (fig 16).

But during these years his ambition for Fyvie as a seat for his
heirs was shattered when his only son died of fever during the
Boer War; people remembered the thirteenth-century curse of
Thomas the Rhymer that the possession of the Castle should not
pass from father to eldest son. His daughter Ethel Louise, Lady Burn
(no 66) was now his sole heir but early in the Great War her elder
son was killed near Ypres. After Lord Leith's death in 1925 Fyvie
was inherited by Lady Burn and her husband who changed their
name to Forbes-Leith. The Castle passed from their second son to
his second son, Andrew, who sold it and most of its contents to the
National Trust for Scotland in 1984.

James Holloway
ASSISTANT KEEPER
SCOTTISH NATIONAL PORTRAIT GALLERY

CATALOGUE OF PAINTINGS

Measurements are given in inches, followed by metres
in brackets.

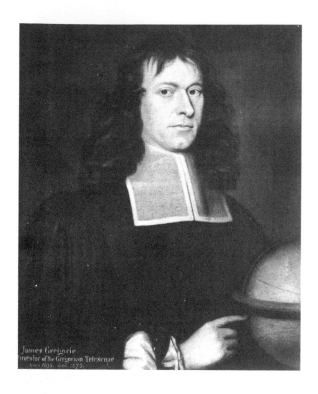

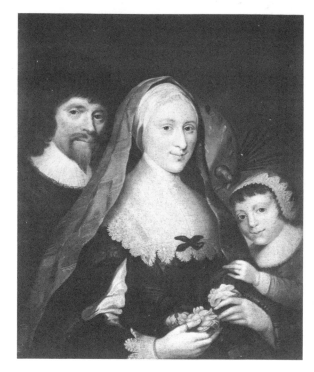

1

James Gregory (1638-1675)

by *John Scougall* (about 1645-1737)

oil on canvas 29¼×23¾ (0.740×0.605)

James Gregory was one of the first of a most remark-able dynasty of mathematicians and scientists which included Dr John Gregory (no 18) and Professor James Gregory (no 36). He was born at the manse of Drumoak on the Aberdeen-Kincardine border and was educated at Marischal College, Aberdeen and Padua. He became Professor of Mathematics at the University of Edinburgh at the age of twenty-three and a year later published *Optica Promota* which contains a description of his invention of the reflecting telescope. His opposition to presbyterianism after the revolution of 1688 led to his removal to England and to his appointment as Savilian Professor of Astronomy at Oxford.

John Scougall was the leading native-born artist working in Scotland at the end of the seventeenth century. He had a studio in Edinburgh and it may have been there, when Gregory was lecturing at the University, that this portrait was painted. It has been in family ownership ever since. Lord Leith, who bought it from a Mr John Gregory at the turn of this century was a descendant of the mathematician on his mother's side.

2

George Jamesone (1589/90-1644) **and his family**

by an unknown artist

oil on canvas 30¼×25½ (0.780×0.650)

Aberdeen-born George Jamesone was the leading painter in Scotland during the first half of the seventeenth century. This portrait of him, his wife and a daughter was bought for Fyvie because Lord Leith claimed descent from Jamesone through his daughter Mary who married the mathematician James Gregory (no 1). Lord Leith probably realised that it was not an original but an old copy. Quite how old is difficult to say. It used to be thought that it belonged to the artist John Alexander in the eighteenth century but it looks later in date and may well have been painted at the beginning of the nineteenth century.

3

John Graham, 1st Viscount Dundee (?1649-?1689)

by *John Alexander* (about 1690-1757)

oil on canvas 30×25 (0.764×0.635)

Inscribed on the reverse: John Alexander AD1732 after the original picture by Sir Peter Lillie

Claverhouse is thought to have come to Fyvie around 1689 to meet Lord Dunfermline about raising support for King James VII and II. Dunfermline, like Claverhouse, was a strong adherent of James and the Jacobite cause, Claverhouse paying for it by his death at the Battle of Killiecrankie, Dunfermline by forfeiture of his estates and exile in France.

Alexander's posthumous portrait of Claverhouse, or 'Bonnie Dundee' as he is also known, was painted in 1732 when hopes were still high, particularly in the north-east of Scotland, for a return to the throne of the exiled Stewarts. Whether the portrait has been at Fyvie since the eighteenth century or whether it was acquired later for its association with the Castle is not known.

4

La Duchesse de la Vallière (1644-1710)

by *Pierre Mignard* (1612-1695)

oil on canvas 42¼×33½ (1.073×0.851)

Francoise-Louise de La Baume Le Blanc, Duchesse de la Vallière was born at Tours in 1644. By the age of seventeen she was the mistress of Louis XIV, bearing him a child. She finished her life as a nun in a Paris convent.

The Duchess holds in her hand an anemone, a flower that was popular and becoming widely cultivated in the seventeenth century. She is dressed in the height of Parisian fashion of the late 1660s, with her loose-fitting gown of elaborately patterned silk and her chemise with its intricate lace frill. Her clothes are rather more elaborate than anything a Scotswoman would have worn at that time.

Mignard's oval canvas has been extended to form a rectangle, possibly in the early nineteenth century when a new frame was fitted.

5

The Wreck of the Spanish Armada

by *Jacob de Gruyter* (active 1650-1675)

oil on panel 29¾×41¾ (0.755×1.061)

This painting of the destruction of the Armada, attributed to the Dutch marine artist Jacob de Gruyter, was painted nearly a century after the event. It would have appealed to English patriotic taste in the seventeenth century and it was probably acquired for Fyvie at the turn of the last century because it appealed to Lord Leith, a former Royal Navy Lieutenant, for similar nostalgic reasons. De Gruyter appears to have been a pupil of Minderhout. Their styles are very similar.

6

A young man

by *Nicholas Maes* (1634-1693)

oil on canvas 45¼×36⅛ (1.143×0.917)

This portrait, traditionally, but probably wrongly, identified as the Earl of Sheffield, is by the Dutch artist Nicholas Maes. As a young man in the 1650s Maes studied in Amsterdam under Rembrandt whose style he absorbed. Later he moved to Antwerp, another great artistic centre, where he learned a different, more fluent and flattering portrait style, one that Rubens and Van Dyck had made popular in the city earlier in the century.

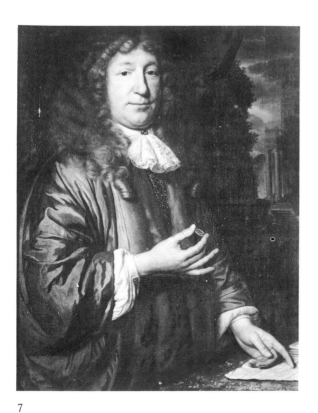

7

A middle-aged man

by an unknown artist

oil on canvas 36×28¼ (0.915×0.717)

This unknown man of the late seventeenth century, wearing an Indian gown, was probably a merchant. Both artist and sitter may have been Dutch. At one time, however, the portrait was thought to represent the great Duke of Lauderdale, Secretary of State for Scotland after the restoration of King Charles II. It was possibly because of that mistaken identification that the painting was acquired for Fyvie, the Duke being the grandson of Alexander Seton, 1st Earl of Dunfermline, the builder of Fyvie's Seton Tower.

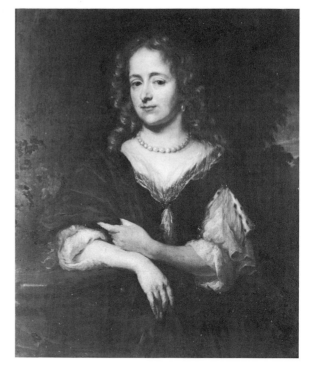

8

A young woman

by *Nicholas Maes* (1634-1693)

oil on canvas 18⅝×15¾ (0.470×0.400)

This small, attractively painted portrait of a young woman, her identity long forgotten, was painted by Nicholas Maes in Amsterdam in about 1680. Where the citizens of Holland had sat to Rembrandt and Frans Hals in the 1650s and 1660s, their children now sat to Maes. They would have appreciated his elegant, modern portrait style which must have made the portraits of their parents look stiff and old fashioned. The pearl necklace and earrings may not have belonged to the young sitter. They appear in other portraits by Maes.

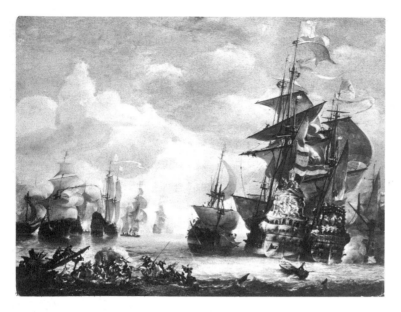

9

The capture of the Royal Prince

by *Hendrick van Minderhout* (1632-1696)

oil on panel 44×58¼ (1.120×1.480)

Signed: H Minderhout

The capture of the *Royal Prince* on 3 June 1666 was the most serious loss to the English fleet in the indeci- sive Four Days Battle against the Dutch. The *Royal Prince* went aground on Galloper Sand, opposite the mouth of the Thames, and was captured and burned. Minderhout was a Dutchman from Rotterdam who specialised in marine painting. His canvases are often enlivened by figures, like those engaged in a skirmish in the lower left hand corner of this painting.

10

James Scott, Duke of Monmouth and Buccleuch (1648-1685)

by *Sir Peter Lely* (1618-1680)

oil on canvas 49¾×40¼ (1.264×1.022)

There are a number of paintings by Sir Peter Lely of James Scott, Duke of Monmouth and Buccleuch. The finest is probably a full-length owned by Monmouth's descendant, the present Duke of Buccleuch. The Fyvie painting which is also of high quality may likewise have been painted as a full-length, but later reduced in size. Monmouth was an illegitimate son of Charles II. He was favoured by his father but rebelled against his uncle James VII and II. Monmouth was defeated at the Battle of Sedgemoor; his rebellion failed and he was executed.

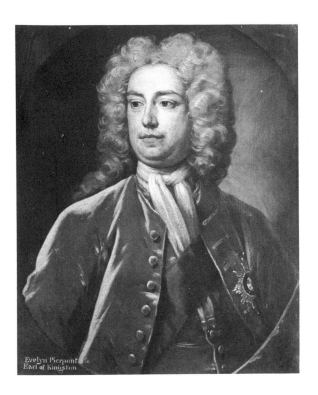

11

Sir Robert Walpole, 1st Earl of Orford (1676-1745)

by *Michael Dahl* (1656/9-1743)

oil on canvas 30×25 (0.763×0.635)

Despite the inscription at the bottom of the painting the sitter is Sir Robert Walpole, the first Prime Minister of the United Kingdom. He is shown wearing the Order of the Garter, a decoration he was given in 1726. Walpole was the first commoner to be awarded the Garter for generations and he was inordinately proud of it, directing that the insignia be carved, painted and plastered all over his newly built Houghton Hall. He also employed artists to paint in the new award on earlier portraits. But the painting of the Garter Ribbon and Star on this work, attributed to the Swedish born artist Michael Dahl, appears to be contemporary with the rest of the portrait and so the work can be dated to 1726 or later.

12

Major William Tennant (died 1803)

by *Thomas Gainsborough* (1727-1788)

oil on canvas 50½×40½ (1.283×1.029)

Major William Tennant of Needwood House, Staffordshire was painted in the 1780s when Gainsborough, back in London from Bath, was challenging Reynolds's self-assumed pre-eminence. Gainsborough had two advantages over his rival: his ability to capture a likeness and a brilliant fluency in handling paint. His weaknesses in comparison with Reynolds were in composition and in portraying personality. Gainsborough's pair to this painting, the portrait of Major Tennant's wife Mary, is now in the Metropolitan Museum of Art, New York.

13

John Monckton, 1st Viscount Galway (1695-1751)

by *John Eccard* (active 1740-1779)

oil on canvas 50×40 (1.270×1.030)

14

William Monckton, 2nd Viscount Galway (died 1772)

by *John Eccard* (active 1740-1779)

oil on canvas 50×40 (1.270×1.030)

These portraits cannot possibly represent John and James Leith as the inscriptions claim. The Leiths were men of the seventeenth century whereas the style and costume of these portraits are clearly much later. Comparisons with portraits of John and William Monckton, 1st and 2nd Viscounts Galway, have suggested this re-identification. The father, John, wears a belt and heavy gloves, the insignia of the Surveyor-General of His Majesty's Honours of Woods, Forests etc in England and Wales to which office he was appointed in October 1748. The portraits must have been painted between then and his death in July 1751. John Eccard has been suggested as the artist. He was a German who worked in London for many years but his paintings are usually smaller in scale.

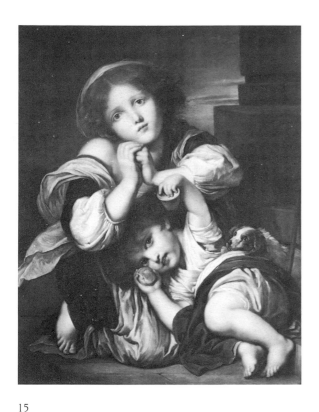

15

The little orphans

by *Jean Baptiste Greuze* (1725-1805)

oil on canvas 35¼×28 (0.895×0.710)

Greuze's beggar children are at first glance attractive
and appealing – eighteenth-century descendants of
Murillo's Sevillian urchins. Yet there is something dis-
quieting about this painting, a hint that the children
are not quite as innocent as they pretend. The hard-
eyed little boy teases his dog while his elder sister,
with an almost hysterical expression appeals not to
the passer-by but to the sophisticated tastes of the
connoisseur, of girls as well as paintings. Greuze was
immensely successful during his early career in Paris
but he fell out of favour and died poor and neglected.

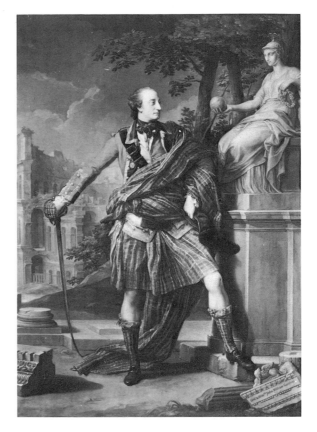

16

Colonel William Gordon of Fyvie (1736-1816)

by *Pompeo Batoni* (1708-1787)

oil on canvas 101⅝×73¼ (2.582×1.861)

Signed: Pompejus Batoni pinxit Romae Anno 1766

This must be one of the most remarkable portraits of
the eighteenth century: a Scottish soldier in full
Highland dress standing in triumph before Rome.
William Gordon of Fyvie wears a 'little kilt' and full
plaid of the Huntly tartan and carries a glengarry –
his nationality not in doubt. But he wears his plaid in
such a way as to suggest a Roman toga and his hose
too, ending at mid-calf, imitate the Roman buskin.
Batoni's portrait of Gordon suggests that in his
military prowess and appearance the Colonel is a
worthy heir of the ancient Romans. This is reinforced
by the statue of Roma, an antique marble from the
Palazzo dei Conservatori, which awards him an orb of
command and a victor's wreath.

 Of all Batoni's many British sitters William Gordon
was not the least entitled to be styled a modern Roman.
He had a distinguished military career seeing active
service in India and held a public position as a Member
of Parliament. His stout defence of the House of

Commons against his nephew Lord George Gordon and his unruly protestant mob during the Gordon Riots is worthy of the pages of Plutarch. It earned him fame at the time and immortality later in the pages of *Barnaby Rudge*. Charles Dickens, who based the passage in his novel from accurate contemporary accounts, made Gordon say: 'My Lord George . . . I desire them to. hear this from me – Colonel Gordon – your near relation. If a man among this crowd, whose uproar strikes us deaf, crosses the threshold of the House of Commons, I swear to run my sword that moment – not into his but into your body!'

Gordon's sword, made by Harvey of Birmingham still survives at Fyvie.

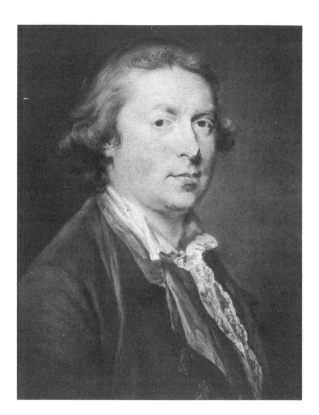

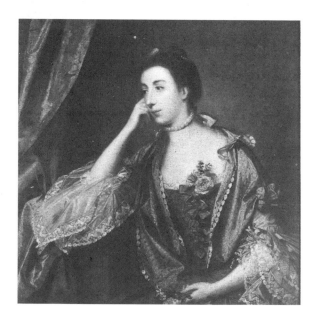

17

Mrs James Fortescue

by *Sir Joshua Reynolds* (1723-1792)

oil on canvas 33×33½ (0.840×0.850)

Mary Hunter, Mrs James Fortescue, seems to have sat to Reynolds several times in the late 1750s and early 1760s.

For this portrait she wore an afternoon dress with elaborate lace sleeves, her hair arranged simply on top of her head and for jewellery only pearls.

Although Reynolds had copies made of Mrs Fortescue's portrait for members of her family, the quality of the painting of her head make it seem likely that this is his own work. He may well have sub-contracted the drapery to a specialist, a common practice in the eighteenth century.

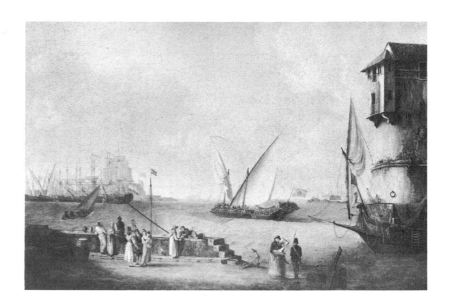

18 *(opposite left)*

Dr John Gregory (1724-1773)
by *Francis Cotes* (1726-1770)
pastel on paper 25×18¼ (0.635×0.463)
Signed and dated: F Cotes pxt 1764

19 *(opposite bottom left)*

The Hon Mrs John Gregory (1720-1761)
by *Francis Cotes* (1726-1770)
pastel on paper 24×18¼ (0.610×0.463)
Signed and dated: F Cotes pxt 1756

John Gregory was the grandson of the astronomer and mathematician James Gregory (no 1), the son of a Professor of Medicine at King's College, Aberdeen and himself a Professor of Philosophy and later of Medicine. In 1766 he was appointed Physician to the King in Scotland. His wife was the daughter of Lord Forbes.

Cotes's portraits of the couple were not drawn at the same time. Elizabeth Gregory sat in 1756 but she had died by the time her husband was portrayed eight years later. The pair of pastels make an interesting contrast, illustrating the development of Cotes's style from the tight, two dimensional image of Mrs Gregory to a livelier and more freely handled portrait of her husband. Cotes's development in these years is typical of the change of direction in British painting in the mid-eighteenth century, moving from the doll-like rococo portraiture of the 1740s and early 1750s to a more relaxed, assured and fluent manner.

20

The Port of Leghorn
by *John Thomas Serres* (1759-1825)
oil on canvas 48½×72½ (1.233×1.842)
Signed and dated: Jn Th Serres 1790

For many men making the grand tour in the eighteenth century the Port of Leghorn was their first sight of Italy. There were regular sailings between there and Marseilles, and Leghorn was the main port of the Grand Duchy of Tuscany.

Serres' painting shows a half galley of the Grand Duke putting to sea and the Medici arms appear on the building in the foreground. Although the picture was not acquired for Fyvie until the 1920s it is an appropriate painting for what was for over a century a Gordon seat.

The 2nd Duke of Gordon was a friend of Cosimo III de'Medici (1642-1723) and the 3rd Duke was christened Cosmo George in his honour. From then Cosmo became regularly used as a Christian name in the Gordon family.

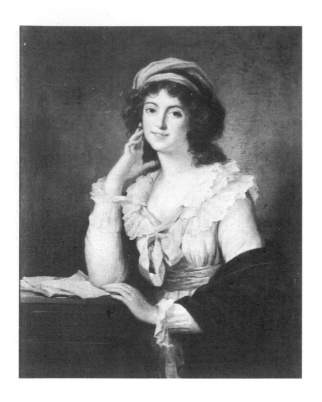

21

Self-Portrait

by *Louise Elisabeth Vigée-Lebrun* (1755-1842)

oil on canvas 40¼×32⅛ (1.022×0.814)

Madame Vigée-Lebrun wears a loose, light and comfortable dress of the sort favoured by French women at the end of the eighteenth century. This free and practical style is now associated with the French Revolution but Madame Vigée-Lebrun, the friend and painter of Marie Antoinette, fled France in 1789. Her subsequent career in a succession of European capital cities was highly successful and she became the most famous female artist of her time.

22

Charles Leslie (1677-1782)

by *James Wales* (1747-1795)

oil on metal 6×4¾ (0.150×0.120)

Charles Leslie, or 'Mussel-Mou'd Charlie' as he was known from his curiously formed mouth, was an itinerant ballad singer in eighteenth-century Aberdeenshire. He was the last of the jockies or joculators, professional minstrels whose ancestry goes back to the bards. Like many in the north-east Charlie Leslie was a Jacobite and his songs, which he wrote himself, were political. The portrait may show a Jacobite camp in the background.

'Mussel-Mou'd Charlie' died in 1782 at the age of 105. His portrait was painted by the Aberdeenshire artist James Wales two years before his death.

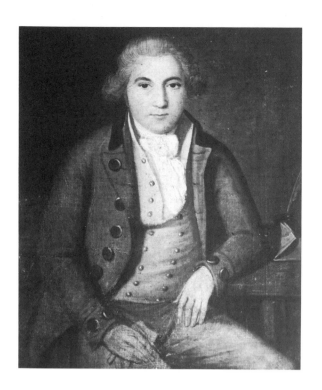

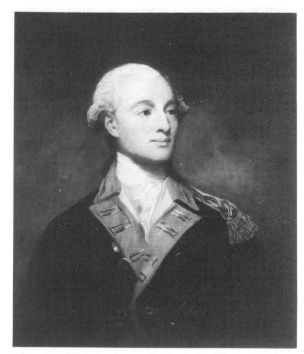

23

A young man

by *David Allan* (1744-1796)

oil on canvas 18¼×15¼ (0.465×0.385)

Signed on the reverse: D Allan Fecit

David Allan's sitters came from the families of the aristocracy and country lairds. Their patronage was undemanding and as Allan grew older he grew careless and his quality declined. Although a modest work this portrait of a serious young man is one of his most appealing. It can be dated to around 1780 shortly after Allan's return from a very successful decade in Italy.

24

Captain Arthur Forbes of Culloden (1760-1803)

by *George Romney* (1734-1802)

oil on canvas 30×25¼ (0.762×0.637)

Captain Arthur Forbes was the son and heir of John Forbes of Culloden and his wife Jane Forbes of Craigievar. Although neither of these branches of the Forbes family was closely related to the Forbeses of Blackford, Lord Leith's ancestors, the Romney portrait probably qualified for the Fyvie collection as the portrait of a kinsman.

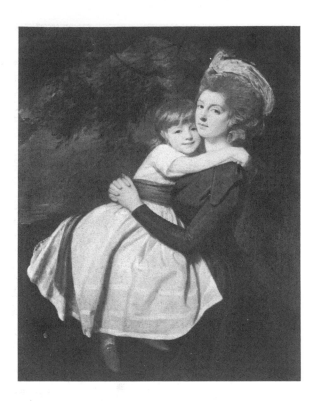

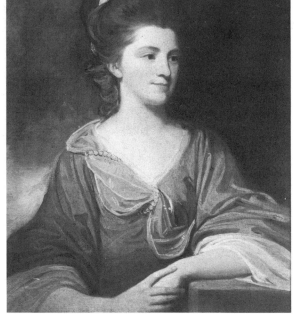

25

Mrs Stratford Canning (died 1831)

by *George Romney* (1734-1802)

oil on canvas 50½×40¾ (1.282×1.035)

George Romney's tender portrait of Mrs Canning and her daughter is one of his finest works, with a striking and complex composition reminiscent of the Madonnas and children of Raphael. Romney was one of the most classical of all English portrait painters and he had only returned from Italy a year or two before he started work on this portrait.

Mehetebel Patrick was born near Dublin and married Stratford Canning from County Londonderry. She was a remarkable woman who on the early death of her husband succeeded him in his business as a merchant and banker until her eldest son was able to take her place.

26

Mrs William Marwood (1743-1807)

by *George Romney* (1734-1802)

oil on canvas 30×25 (0.763×0.635)

Mary Marwood sat four times to Romney in the spring of 1778, each sitting lasting about an hour. Her portrait cost eighteen guineas, much less than Mrs Canning (no 25) whose portrait Romney was also painting at this time – she sat twenty-six times and was charged fifty guineas. Mrs Marwood was the daughter of Christopher Goulton of Beverley in the East Riding of Yorkshire. It seems that he commissioned this portrait of his daughter after she had left home to marry William Marwood who lived in the North Riding.

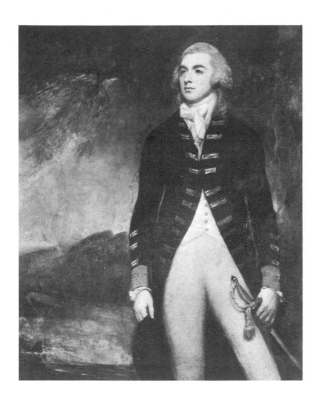

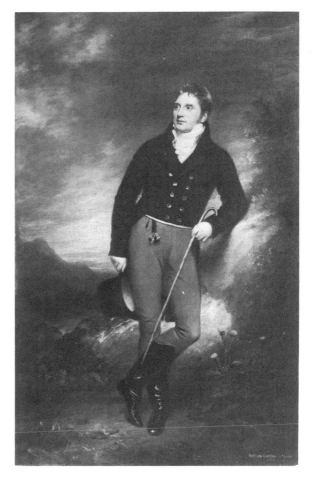

27

John West, 4th Earl de la Warr (1758-1795)

by *George Romney* (1734-1802)

oil on canvas 60½×48½ (1.537×1.232)

John Richard West succeeded his elder brother William to the de la Warr earldom in January 1783. In March that year the new Earl began to sit to Romney. He married in April and set up house at 4 Saville Row where Romney's glamorous portrait was almost certainly hung. Lord de la Warr is shown wearing the full dress version of the Windsor uniform. He was an equerry to Queen Charlotte until 1783 and from 1789 to 1795 a lord of the bedchamber to King George III.

28

William Gordon of Fyvie (1776-1847)

by *Sir William Beechey* (1753-1839)

oil on canvas 92×57 (2.340×1.450)

Signed and dated: W Beechey Pinx 1817

This is one of Beechey's finest portraits, a glamorous and romantic image of an unusual and talented man. William Gordon was born the illegitimate son of General Gordon and one of his servants, Isobel Black. In old age the General married William's mother which under Scots law legitimised their son. On his father's death in 1816 he inherited Fyvie. Within months William Gordon sat to Beechey and was soon improving the Castle and its grounds. He built up the collection of paintings, added to the Fyvie library and made an observatory. Beechey painted his portrait in London but the background is generalised to suggest Scotland. The clump of thistles has the same purpose.

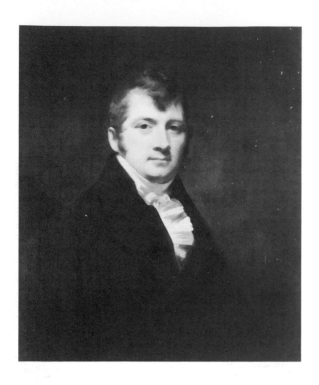

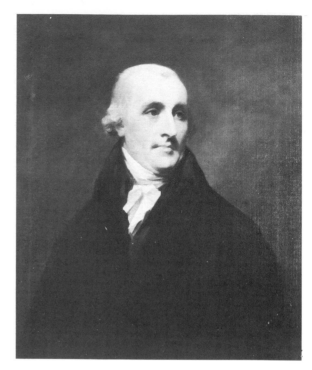

29

George Bell (active 1798-1830)

by *Sir Henry Raeburn* (1756-1823)

oil on canvas 30¼×25¼ (0.770×0.640)

George Bell, surgeon, became a burgess of Edinburgh on 28 March 1798. He was a younger brother of the better-known surgeon, Benjamin Bell (1749-1806). He is presumably the Mr George Bell who is recorded in the Royal Infirmary in Edinburgh in 1815.

A label on the reverse of the picture written by his granddaughter Margaret A Stewart states that he was a surgeon-extraordinary to both George IV (reigned until 1830) and William IV. She also dates the painting to 1801-2, which is so specific as to suggest there is good reason for it.

There are no other records of this portrait but it is certainly by Raeburn. The rather thick, linear quality of the paint within the facial features is typical of his work at this period.

30

Alexander Edgar (died 1820)

by *Sir Henry Raeburn* (1756-1823)

oil on canvas 29¾×24¾ (0.752×0.630)

The sitter was the eldest son of Alexander Edgar of Auchingrammont (1698-1777) in Lanarkshire and Margaret Edgar, a relative from the Wedderlie (Berwickshire) branch of the family: they married in 1742. At some time in the eighteenth century the family owned property in Jamaica, also called Wedderlie, but their principal properties appear to have been in Edinburgh and Leith. Alexander surrendered his rights in Auchingrammont to his younger brother, James, in 1783. He married Anne Gordon in 1793 and they had eleven children. He died on Christmas day 1820 and was buried in St Cuthbert's churchyard in Edinburgh.

There is also an interesting Raeburn connection. Alexander Edgar's uncle, Peter Edgar of Bridgelands in Peebles was the father of Anne Edgar who, having been widowed by the death of her first husband, James Leslie of Deanhaugh, married Henry Raeburn, probably in 1780.

The portrait is remarkably austere with little of Raeburn's usual delight in the act of painting. An inscription on the reverse of the stretcher, added in 1876 by Raeburn's grandson, Logan White Raeburn, vouches for its authenticity.

31

Lieutenant-Colonel Henry Knight Erskine
(active 1780-1794)

copy by *Sir Henry Raeburn* (1756-1823)

oil on canvas 30×25 (0.762×0.635)

A contemporary inscription in ink on the reverse of the stretcher records the identity of the sitter and the circumstances in which Raeburn made the painting, as follows: *Lt. Colonel Henry Knight Erskine of Pittodrie Senr. 1780/Married Miss Mary Erskine of Pittodrie/Copied by Reaburn* (sic) *from a Miniature/1815.*

Raeburn's activities as a copyist – and a highly accomplished one – are discussed at greater length under the portrait of the Duchess of Gordon (no 32). Although always able to convey to a remarkable degree the stylistic 'feel' of the artist he is copying, his own manner of handling paint usually remains firmly in evidence. However, the balance here is tipped in favour of the copied artist, so much so that it can be said with near certainty that the original miniature (which is not known) must have been the work of Richard Cosway (1742-1821). The rather chalky effect of the colour, the angle of the head, and the slightly sentimental air, are all typical of the miniature painter.

The sitter is shown in the undress uniform of a Major in the 21st Regiment, the rank he held between 1784 and 1789. In the latter year he became Lieutenant-

Colonel in the 27th (Inniskillen) Regiment. By 1790 he is listed as 'Henry Erskine Knight', possibly the year in which his wife, the heiress Mary Erskine, daughter of Thomas Erskine and his second wife, Anne Forbes, came into her inheritance. He left the army in 1794.

32

Jane, Duchess of Gordon (1749-1812)

copy by *Sir Henry Raeburn* (1756-1823)

oil on canvas 30×25 (0.762×0.635)

Although catalogued by Sir William Armstrong (1901) as by Raeburn, without qualification, this painting is clearly a copy by Raeburn of a portrait at Goodwood by Sir Joshua Reynolds; and when sold by Agnew's to Lord Leith in November 1901 its status as 'Raeburn after Reynolds' was specifically noted.

There are indications that Raeburn had financial problems in the first decade of the nineteenth century, possibly because of his involvement with his eldest son, Henry, in an insurance brokerage firm which collapsed. This may be the explanation for the quite considerable number of copies of other artists' work which he produced, otherwise surprising for an artist

of such well-established reputation. Although always remarkably faithful to the original in these copies Raeburn, perhaps because he was released from the usual problems of drawing and articulating a figure seen in three dimensions, was able to seize the opportunity (as here) to indulge in some supremely felicitous, even ravishing abstractions of deeply textured, deftly applied paint.

The original portrait was exhibited at the Royal Academy in 1775. By then the Duchess, second daughter of Sir William Maxwell of Monreith and Magdalen Blair, had been married to Alexander, 4th Duke of Gordon for eight years. A remarkable beauty, she is said to have had 'an unscrupulous desire for family aggrandisement' and her 'good nature and ready wit' to have been 'marred by singular coarseness of speech'. She became estranged from her husband in later life and was to die in some distress in a Piccadilly hotel, although her son George, the future 5th Duke (no 33), was by her side. When the latter was raising the 100th Gordon Highlanders (later the 92nd Foot) on the family estates in 1794 the Duchess is said to have sported the regimental colours and to have held the recruiting shilling between her lips.

33

George, 5th Duke of Gordon (1770-1836)

by *Sir Henry Raeburn* (1756-1823)

oil on canvas 30¼×25¼ (0.769×0.641)

George Gordon was noted as a boy of great spirit and good looks at Eton. In 1778 he was included in a famous double portrait with his mother by George Romney, which now hangs in the Portrait Gallery. He entered the army at the age of twenty, when he was still Marquis of Huntly – he did not succeed his father as 5th (and last) Duke until 1827. A long and varied career (Lieutenant-General in 1808) culminated in his being made General in 1819, which could be the date of the portrait – he wears a General officers' uniform of a type which is post-1811.

Mrs Grant of Laggan in her *Letters from the Mountains* describes him in 1802 and, although that is a number of years earlier than the portrait, her verbal picture attests to the descriptive truth of the portrait and to the kind of man we sense behind the outward features: '. . . he has lost the boyish looks he long retained, but appears manly and decided. He has his mother's fine eyes, and, on the whole, is a genteel, spirited figure, with a countenance animated and penetrating; and so ought it, for he observes like our gillieroy – nothing escapes him.'

Nevertheless, by the time he painted this portrait,

Raeburn had left behind, if not actually disowned, much of the simple realism of his earlier work. From about 1810, when he became more conscious of styles in London, and increasingly until his death in 1823, many of his portraits become charged with a romantic, almost ecstatic quality. As here, the figure is viewed from a particularly low angle, with the shadows beneath the upper eyelids and on the upper lip exaggerated. The eyes themselves become over-large and their luminosity is emphasised by a long highlight which runs from the iris well into the white, directing them towards some almost unearthly prospect.

34 *(opposite right)*

Charles Gordon of Buthlaw, Lonmay, and Cairness (1747-1797)

by *Sir Henry Raeburn* (1756-1823)

oil on canvas 35×27 (0.890×0.680)

Charles Gordon was the only son of Thomas Gordon, a merchant in Aberdeen, and Jean Barclay, daughter of the Revd John Barclay, episcopal minister of Peterhead. In 1775 he succeeded an uncle as 7th Laird of Buthlaw. He acquired the lands of Cairness from his mother

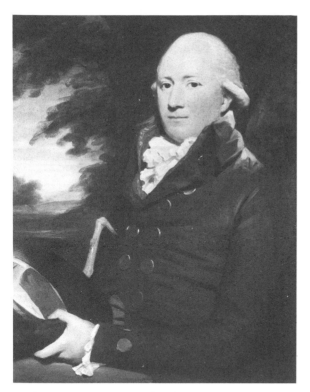

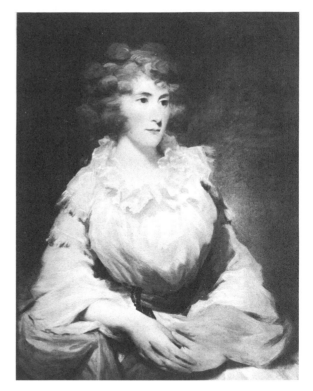

35

and her sister in 1776 and bought the estate of Lonmay in 1796, the year before his death.

The relining canvas attached to the back of the original is inscribed in a cursive style that is likely to be a copy of a contemporary inscription: *Charles Gordon Esqr./of Buthlaw/Raeburn pinxit* A.D.1790.

The whole picture is rather roseate in colour but there is a formal contrast between the lushness of certain areas and the sober realism of others. The foliage in the background is painted in a series of broad, rounded brushstrokes, the paint pulled one way, turned and brought back to the starting point in one movement. (This is the same method used for the hair in the companion portrait of Gordon's wife (no 35).) On the other hand the face is painted in a subdued, deliberate manner, rather as might be expected from a miniature painter turning to paint life-size, as Raeburn had done. All this suggests that the date in the inscription is an accurate record.

Christian Forbes, Mrs Charles Gordon

by *Sir Henry Raeburn* (1756-1823)

oil on canvas 35×27 (0.890×0.680)

Christian Forbes was the daughter (and co-heir) of Charles Forbes of Ballogie and Christian Cumming. She married Charles Gordon of Buthlaw (no 34) in 1783. Their son Thomas was to play an important role in the struggle for Greek freedom and published a *History of the Greek Revolution* in 1832.

Although close in date this picture may not have been painted at precisely the same time as its companion (no 34). There is a slight discrepancy in scale (see also nos 36 and 37), the backgrounds are unrelated, and the contemporary frames, although similar, are not identical in detail. Her dress and hands, composed of quite straight, sharply interlocking brushstrokes, are painted with less concern for simple description than the corresponding parts of the male portrait.

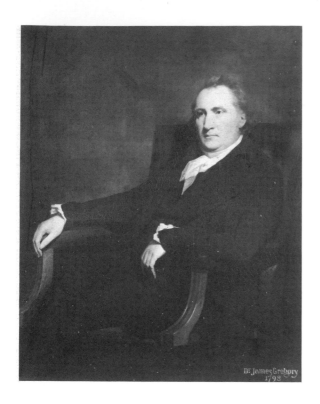

36

Professor James Gregory (1753-1821)

by *Sir Henry Raeburn* (1756-1823)

oil on canvas 49½×40 (1.259×1.016)

Gregory was a member of a remarkable medical and scientific family whose endeavours spanned five generations. His great-grandfather James (see no 1) was the inventor of the reflecting telescope, his grandfather James was Professor of Medicine at King's College, Aberdeen, while his father John (see no 18) was Professor of Medicine at Edinburgh. Gregory was appointed to his father's old chair in 1790 on the death of the great physician, William Cullen. Two of his sons by Isabella Macleod (no 37) whom he married in 1796 were distinguished in mathematics and chemistry.

He was a man of immense energy, with wide scientific and philosophical interests, but he tended to dissipate his powers in needless controversy, which won him many enemies in the medical establishment. Lord Cockburn in his *Memorials* describes him as 'a curious and excellent man ... a great Latin scholar, and a great talker, vigorous and generous, large of stature, and with a strikingly powerful countenance'.

That Raeburn's portrait is successful as a likeness is confirmed by an etching done by John Kay in 1795, which shows Gregory in profile and wearing the uni-

form of the Royal Edinburgh Volunteers. He was an enthusiastic but not very competent soldier and his sheer mental energy is said to have provoked his drill sergeant to shout: 'Damn it, sir, you are here to obey orders, and not to ask reasons: there is nothing in the King's orders about reasons! ... I would rather drill ten clowns than one philosopher.'

A series of old labels on the back of the frame, attached in the early nineteenth century when the picture was either at the family house of Canaan Lodge in Edinburgh or at the home of Gregory's daughter in Grosvenor Square, London, state that the portrait was painted by Raeburn 'about 1798'. This date, without qualification, was later inscribed on the canvas. There seems little reason to doubt it, although, lacking this evidence, there might be a temptation to believe that it and its supremely beautiful companion (no 37) were painted to celebrate the marriage of 1796.

37

Isabella Macleod, Mrs James Gregory (1770-1847)

by *Sir Henry Raeburn*

oil on canvas 49½×40¼ (1.257×0.022)

Among Raeburn's work this portrait is of unsurpassed delicacy and simplicity. It has wonderful clarity of outline and the simple colour scheme is a variation on white and green. In terms of handling there is nowhere

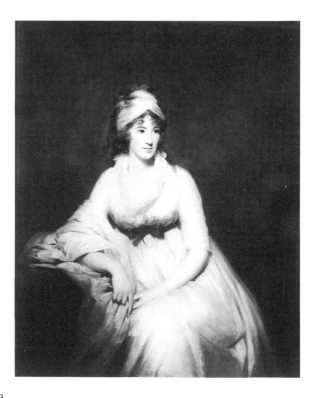

in his work such a delicious painterly concoction as the whorls of pale brown and dashes of grey and creamy white that make up the hair and turban-style bandeau.

But there is evidence that it was not always quite so simple. Under the warm, silvery green background there were once trees and foliage. Raeburn's reason for painting them out (almost certainly to the portrait's great gain) was perhaps not an aesthetic one but so that the background would conform to the portrait of Professor Gregory (no 36) – there is evidence that the background in that portrait is discoloured and if cleaned would be closer to that in its companion. This, and a distinct discrepancy of scale, suggests that Raeburn did not have both portraits in his studio at the same time. Another hint that they may have been painted at slightly different dates and then made into a 'pair' is the fact that the original frames, although very similar in detail, have subtle differences.

Isabella Macleod was the daughter of Donald Macleod of Geanies, Sheriff of Ross, and his first wife, Margaret Crawford. She married James Gregory, as his second wife, on 28 October 1796, in the parish of Canongate.

Both portraits were bequeathed in 1881 to the sitter's grand-niece, Margaret Forbes, wife of Rear-Admiral John Leith. She, in turn, bequeathed them to her daughter, Mrs Patrick Stirling of Kippendavie, whose son John sold them to his uncle, Alexander Forbes-Leith, later Lord Leith of Fyvie.

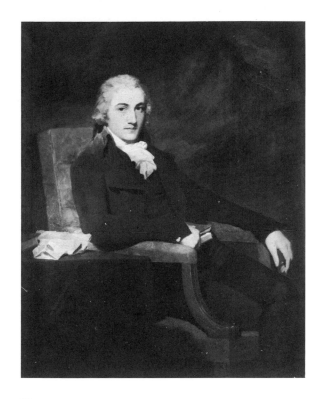

38

Thomas King (about 1772-1802)
by *Sir Henry Raeburn*
oil on canvas 50×40 (1.270×1.016)

James King of Drums, in the parish of Erskine in Renfrewshire, the father of Thomas, was made a merchant burgess of Glasgow in 1793 at the same time as his eldest son Matthew. Matthew, however, who had acquired the nearby lands of Millbank died in the same year and Thomas succeeded him.

Thomas studied law, and became advocate in 1794, but seems to have been more interested in rural affairs and purchased other lands on the south bank of the Clyde-Gledoch in 1795 and Park Erskine in 1801. He married a Christian Wallace in 1797 but died at the early age of thirty on 22 October 1802. At this time his father, James, was still living and the traditional identification of the portrait as Thomas King of Drum (correctly, Drums) is at least partly inaccurate: more precisely he should be designated as of Millbank, Gledoch, and Park Erskine.

The portrait must be close to 1800 and is of a rather standard Raeburn type.

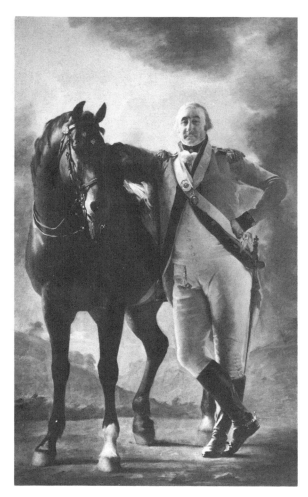

1795 to 1801. Even if the baronetcy has been over-looked in the list, there is a problem in that the epaulettes on both shoulders indicate a rank of Major or Lieutenant-Colonel. These difficulties are further compounded by the fact that a William Maxwell, baronet, is recorded as a Major in the Lowland (West) Fencibles from 1794, but the uniform shown in the painting does not belong to that regiment.

There can, however, be little doubt that sitter and artist together worked out in detail the actual content of the picture, from the badges, the sword (of a type introduced officially in 1796 but in use a year or two earlier), down to the magnifying glass in Maxwell's left hand.

Raeburn was much interested in the *contre-jour* or back lighting effects used in this painting in the 1790s. Crucial areas are defined in rings of quite pure light – the shape of Maxwell's skull, right cheek, and nose, for example – leaving much else in shadow. Within these shadows a series of stronger darks and finely modulated half-tones continue the description of the forms outlined in light.

40

Professor Thomas Reid (1710-1796)

by *Sir Henry Raeburn* (1756-1823)

oil on canvas 29¾×25 (0.757×0.635)

Thomas Reid was the son of Lewis Reid, minister of Strachan, and Margaret Gregory, a member of the

39

Sir William Maxwell of Calderwood (1748-1829)

by *Sir Henry Raeburn*

oil on canvas 96×60 (2.440×1.525)

This portrait has frequently been identified as General Sir William Maxwell, 7th baronet of Calderwood, who was active in the American War of Independence. But, since the subject wears the order and orange ribbon of a baronet of Nova Scotia, and as the painting on stylistic grounds belongs to the 1790s, it must represent the 6th baronet, of the same name, who succeeded to the title in 1789 (the General, his cousin, did not succeed until 1829).

However, one or two problems remain. The badge on the shoulder belt indicates that the sitter is an officer of either the 3rd Foot Guards or the 1st Regiment of Foot. No Maxwell is listed in the 3rd Foot Guards at this time but a William Maxwell, not designated as a baronet, is recorded as a Captain in the 2nd Battalion of the 1st Regiment of Foot from

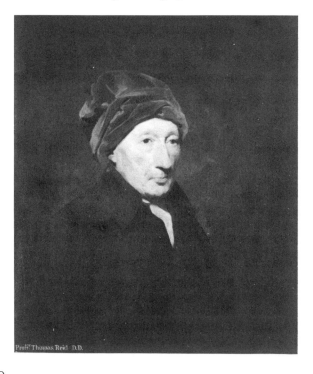

Prof.r Thomas Reid D.D.

remarkable family whose achievements are outlined above (no 36). Having studied philosophy and divinity he was for a number of years minister at New Machar, before becoming Professor of Philosophy at King's College, Aberdeen, in 1751. In 1764 he published his major work, *Inquiry into the Human Mind*, and in the same year he was elected Professor of Moral Philosophy at Glasgow, a chair he held until his death. His 'common sense' (or rational) philosophy was influential throughout Europe and he was highly regarded by Schopenhauer.

Reid was also profoundly interested in scientific matters and sustained a friendship with his distant cousin, James Gregory (no 36). There is a well-established tradition, which makes sense in a number of ways, that Raeburn's portrait was painted during a visit to Gregory in Edinburgh in 1796, just a few weeks before his death. He is clearly very old and frail in the portrait and stylistically the rather dry, almost tentative manner in which the face is painted, allied to the bravura handling of the red nightcap, is typical of Raeburn at this time. In addition, the portrait remained in the Gregory collection, perhaps as a memorial to the friendship.

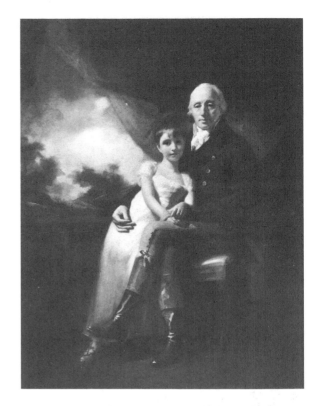

41

John Stirling of Kippendavie (1742-1816) **and his daughter, Jean** (1804-1859)

by *Sir Henry Raeburn* (1756-1823)

oil on canvas 78×60 (1.981×1.524)

John Stirling succeeded his elder brother, Patrick, in the family estate of Kippendavie in 1775. He married Mary Graham, daughter of William Graham of Airth, in 1781 and they had thirteen children. His youngest daughter, Jean Wilhelmina, who appears in the portrait with him, was to become the friend and benefactor of Chopin; with her sister, Mrs Erskine, she arranged the composer's visit to Scotland in 1848. On suggestions that he might marry her – and she clearly loved him – Chopin remarked that she was 'much too like me. How can one kiss oneself?' After the composer's death Jane Welsh Carlyle noted her disconsolate figure in the street, pale and dressed in black, 'like Chopin's widow'.

On the evidence of the child's age the portrait must have been painted about 1813. The painting is unsatisfactory in a number of ways and shows traces of the same striving after effect that is a feature of Raeburn's self-portrait of 1814-15 when he clearly had a London audience in mind. His wonderful lack of inhibition has tended to give way to laboured handling and an unhappy jostling of disparate styles. While Stirling's head

is painted with elaborate refinement the child's head and body are rather summarily treated, in a way reminiscent of Raeburn's pupil, George Watson. Raeburn's early interest in meticulously recording the structure of everyday objects is evident in the child's right shoe, while his bravura style of conveying information has become almost peremptory in the dashed-in highlights of Stirling's boots. The least satisfactory part of the painting is Stirling's right hand which has been so many times redrawn in paint that it is quite out of scale and makes a painful contrast with the sensitively lit fingers of the child's left hand. The chair itself seems to give way under the strain.

Yet, when all these criticisms have been made, it has to be said that the picture has much charm. Through all the faulty drawing there shines a very sensitive reflection of the relationship between a very elderly father and a young child.

42

A young woman

by *John Downman* (1750-1824)

watercolour on paper 8¾×7¼ (0.220×0.185) oval

Signed and dated: JD 1799

The identity of this pretty young woman with her magnificent hat is not known. She must have sat to Downman in London where the artist had a busy and fashionable practice. The revival of interest in things eighteenth-century at the end of Victoria's reign brought Downman back into favour. The small scale and unassertive colouring of his portraits made them perfect accessories for the interior decorator.

43

A young woman

by *John Brown* (1749-1787)

pencil on paper 24¼×16¼ (0.615×0.410)

John Brown, one of the most original draughtsmen of the eighteenth century, was a native of Edinburgh. At the age of twenty he left for Italy where he worked alongside Fuseli, Sergel and other pioneers of the romantic movement. Brown was also an authority on Italian music.

He returned to Edinburgh after almost twelve years abroad and under the patronage of the Earl of Buchan produced large pencil portraits of eminent Scotsmen for Buchan's projected Temple of Caledonian Fame – a precursor of the Scottish National Portrait Gallery. The unconventional head-dress and unfashionable plaits make it unlikely that this drawing was commissioned, certainly not for Lord Buchan's Temple. The sitter is unknown; possibly she is Mary Esplin who married Brown in 1786 a year before his early death.

44

Courtship in the Park

by *John Opie* (1761-1807)

oil on canvas 56×46½ (1.422×1.181)

In 1781 John Opie was launched in London as the Cornish Wonder, a new Rembrandt. Sir Joshua Reynolds considered him 'like Caravaggio, but finer!' What his contemporaries admired was the strength of his composition and his manipulation of light and shade. Sixteen years later when *Courtship in the Park* was exhibited at the Royal Academy it was the critics rather than the artist who had changed. 'There is a heaviness of style and a muddiness of tint which is not pleasing' wrote the *Morning Post* about this painting. 'If he would copy a few pictures from the Venetian School, it would amend his manner wonderfully.'

45

Lady Kerrison (1738-1825)

by *John Opie* (1761-1807)

oil on canvas 52×41 (1.321×1.041)

Mary Kerrison was two years older than her husband, a tavern waiter who made a spectacular fortune in banking and became Lord Mayor of Norwich and High Sheriff of Norfolk. Sir Roger died of apoplexy in 1808 the year in which his bank failed. Lady Kerrison survived him for another twenty-seven years. Opie painted this portrait as a pair to one of Sir Roger. They remained together until about 1900 when the London art trade separated them, Lady Kerrison going to Fyvie, her husband to New York.

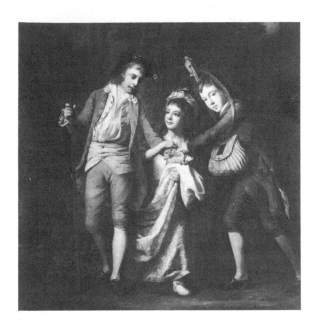

46

The Erskine Children

by *Nathaniel Dance* (1735-1811)

oil on canvas 60¾×60 (1.545×1.523)

James, John and Henrietta Maria were the three children of Sir Henry Erskine of Alva, a soldier and Member of Parliament. James, his eldest son, shown holding a staff, inherited his father's baronetcy, his uncle's earldom of Rosslyn and became a rich man. He was the leader of the Tories in the House of Lords and an intimate friend of the Duke of Wellington.

The artist Nathaniel Dance had similar good fortune. He married a rich widow, entered politics and was created a baronet. At his death he was worth about £200,000 and had long abandoned portrait painting.

47

Horatio, 1st Viscount Nelson (1758-1805)

by *John Hoppner* (1758-1810)

oil on canvas 91¾×58 (2.330×1.495)

This portrait of England's greatest admiral was painted shortly after the Battle of Copenhagen of 1801 which is shown in the background. It was a most important victory for Great Britain as it destroyed the Danish fleet and with it the very real possibility of a hostile naval alliance of Russia, Sweden and Denmark. Nelson was made a Viscount and he is shown wearing honours from previous victories, in particular the gold medals around his neck awarded for the Battles of St Vincent and the Nile. Hoppner's original of this portrait was painted for the Prince of Wales and is still in the Royal collection. This fine version, said to have been painted for Emma Hamilton, was bought by Lord Leith from Lord Bridport in 1895. Lord Leith had a copy made of it which he presented to the Naval and Military Club in London.

48

Spranger Barry (1719-1773)

by an unknown British artist

oil on canvas 30×24¾ (0.760×0.630)

Spranger Barry, one of the greatest actors of the British stage, was born in Dublin where he began his career. It was there that he met Garrick, who became a colleague and a rival. The London public had the opportunity to judge their merits when in 1750 Barry and Garrick starred in rival productions of *Romeo and Juliet*, Barry with Mrs Cibber as his Juliet at Covent Garden, Garrick with Miss Bellamy at Drury Lane. Barry, a strikingly handsome man, won most tears according to the critics; Garrick won most applause. This anonymous portrait shows the liveliness and good looks of the actor.

49

Robert Lovelace (died 1821)

by *Tilly Kettle* (1734/5-1786)

oil on canvas 30×25 (0.760×0.635)

This portrait was formerly attributed to Nathaniel Dance but with its air of wistfulness, strong triangular composition and a similarity to Reynolds's early portraits it seems much closer to the work of Tilly Kettle. Kettle worked in the English midlands and in London before sailing east to make his fortune painting the soldiers and nabobs of British India.

Robert Lovelace of Quiddenham Hall was a Norfolk squire.

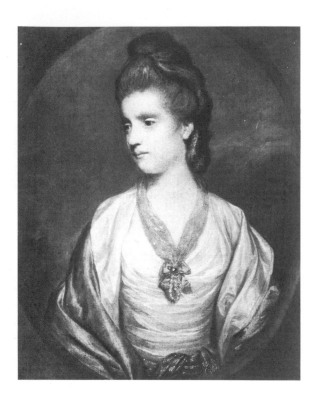

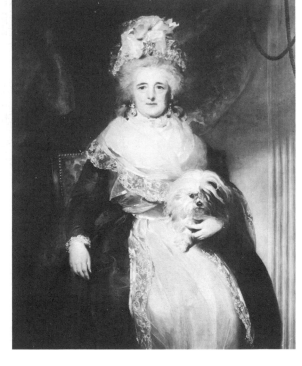

50

Elizabeth Fortescue, Countess of Ancram (1745-1780)

by *Sir Joshua Reynolds* (1723-1792)

oil on canvas 30×25 (0.762×0.635)

Elizabeth Fortescue married William Kerr, heir to the earldom of Ancram and the marquisate of Lothian, in 1762. She was a cousin of the great Duke of Wellington, a most useful relation for a woman with nine children and numerous grandchildren, many of whom went into the armed services.

Several portraits of the Marchioness by, or attributed to, Reynolds survive. This one seems to have been painted towards the end of the 1760s.

51

Susanna Archer, Countess of Oxford (1728-1804)

by *Sir Thomas Lawrence* (1769-1830)

oil on canvas 50×40 (1.270×0.910)

Thomas Lawrence was a child prodigy, exploited by his father who brought him to London at the age of eighteen to challenge England's leading portrait painters. This he successfully did and after Reynolds's death in 1792 there was no one to compare with him for originality, vivacity and sheer painterly technique.

Lawrence was a slow and painstaking artist and he may have worked on this portrait over a number of years. It is sharply observed yet sympathetic. Susanna Archer had been a great heiress – she wears the most spectacular diamond earrings and brooch. She married the 4th Earl of Oxford in 1751. He was also painted by Lawrence.

52

Mrs Paul le Mesurier

by *John Hoppner* (1758-1810)

oil on canvas 30×25 (0.763×0.635)

This is one of Hoppner's most attractive paintings, a sympathetic portrait of a rich City of London merchant's wife. Paul le Mesurier was a director of the East India company, a Member of Parliament and a Lord Mayor of London. He came, and probably his wife did too, from a Channel Islands family.

Margaret le Mesurier is shown wearing a dress inspired by Van Dyck; seventeenth-century revival costume had been fashionable for much of the eighteenth century. Hoppner was patronised by the Prince of Wales and was understandably jealous of the abilities of his younger rival Thomas Lawrence who replaced Reynolds as Painter-in-Ordinary to the King.

53

Soldiers and Sailors decorating a monument commemorating the Battle of Alexandria

by *Philippe de Loutherbourg* (1740-1812)

pen and wash on paper 27¾×22¾ (0.705×0.577)

Signed and dated: P J de Loutherbourg RA inv & del: 1804

De Loutherbourg's drawing commemorates the victory of the Battle of Alexandria of March 1801 against the French. Sailors and soldiers are shown decorating an Egyptian pyramid with portraits of the officers who took part in the battle. At the top is hung a portrait of their general, Sir Ralph Abercromby, born at Menstrie in Clackmannanshire, who died during the course of the battle. The victory was of great importance in the war against Napoleon, not only because it removed his threat to British India, but because up to that time Napoleon's armies had seemed invincible.

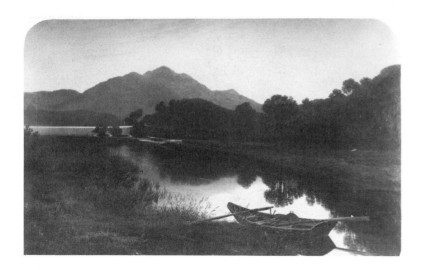

54

Outlet of Loch Achray

by *Waller Paton* (1828-1895)

oil on canvas 28¼×43¼ (0.715×1.097)

Loch Achray lies in the heart of the Trossachs, a district made famous by Sir Walter Scott who in 1810 published *The Lady of the Lake*. By association with the poem the Trossachs and soon all the Highlands became regarded as a landscape of primitive and unsullied beauty where the Victorian tourist could spend a remote, simple and idyllic holiday.

Waller Paton's still evening landscape was one of many such pictures which were painted as souvenirs of a scene and an experience.

55

Self-Portrait

by *James Giles* (1801-1870)

oil on canvas 23⅞×19¾ (0.607×0.502)

Signed and dated: J Giles RSA ipse pinxit
1846 aetatis suae 45; and inscribed: James Giles RSA painted by himself to William Gordon of Fyvie Castle

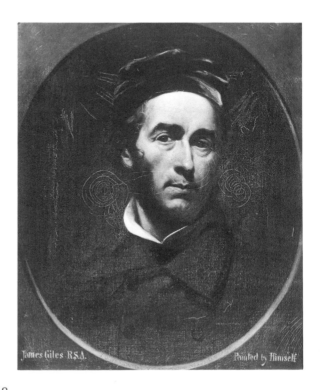

James Giles is first known to have visted Fyvie at the age of nineteen when he drew the Castle on a walking tour from Glasgow to Aberdeen. He soon made friends with William Gordon of Fyvie who encouraged his career by commissioning works and introducing him to potential patrons. Giles presented his friend with this self-portrait painted at the age of forty-five. Giles's career was very successful. It was the sight of his watercolours of Balmoral that persuaded Queen Victoria to buy the castle as her Scottish home. He later worked for the Royal family and for many of the other great landed families of the north-east.

56

Landscape with deer

by *James Giles* (1801-1870)

oil on canvas 36×28¼ (0.914×0.717)

Signed and dated: J Giles 1831

57

Landscape with a waterfall

by *James Giles* (1801-1870)

oil on canvas 36×28¼ (0.914×0.717)

As well as a painter James Giles worked as a landscape gardener at Balmoral, Haddo and at Fyvie. It is tempting to think that this pair of landscapes depicts views on the Fyvie policies which Giles helped to design. They look, however, more typical of the scenery of Upper Deeside or Strathdearn, country often painted by the artist. Giles's two landscapes contrast a morning and an evening scene.

58

A hurricane off Cape Hattrass; The Thracian throwing her guns overboard

by *William Huggins* (1781-1845)

oil on canvas 16×22 (0.405×0.560)

Signed: W J Huggins

The *Thracian* was a brig sloop of the 'cruiser' type built in 1809 for the Napoleonic wars. The dramatic incident depicted by the marine artist William Huggins shows the *Thracian* throwing her guns overboard during the course of a hurricane off the coast of North Carolina. Andrew Forbes was in command and he probably commissioned this painting to record that remarkable and perilous event. Forbes was promoted to Captain in 1834. He was Lord Leith's great uncle.

59

The Trial of Charles I

by *John Burnet* (1784-1868)

oil on panel 32×45 (0.813×1.143)

The painting was bought for the collection in 1906 as the work of Sir David Wilkie. That was an understandable error as John Burnet's style and subject matter were similar to Wilkie's; in fact Burnet's composition is modelled on Wilkie's painting *Knox Preaching*. It was almost certainly the subject matter, Charles I, rather than the attribution which interested Lord Leith. Charles had spent part of his childhood at Fyvie and Lord Leith was keen to acquire works of art which were associated with the Castle and its history.

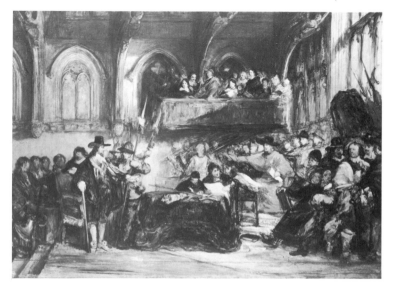

60

The Sound of many waters

by *Sir John Millais* (1829-1896)

oil on canvas 58×84 (1.475×2.135)

Signed in monogram and dated: 1876

'Dearest Mary', wrote Millais to his daughter on
9 November 1876 as he worked on this painting, 'I
fear that, after all, I shall have to give my work up
and finish it next year, as there is nothing but snow
overall, and I have a cold as well, which makes it
positively dangerous to paint out in such weather as
this. However we shall see what tomorrow brings. It is
dreadfully dull here when there is nothing to do. I
have been in my hut this morning and I hoped a blink
of sun would thaw sufficiently the snow on the fore-
ground rocks to enable me to get on, but the storm is
on again, and it is simply ridiculous trying to work, as
everything is hidden under a white sheet'.

Whisky and improved weather helped Millais finish
his painting at Rumbling Brig, near Dunkeld. It was
exhibited at the Royal Academy the following year.

61

A Cavalier

by *John Pettie* (1839-1893)

oil on canvas 42¾×36¾ (1.087×0.934)

Signed: J Pettie

In his accurate depiction of costume, armour and
accessories Pettie has produced a believable image of
a cavalier. But one would be wrong to imagine that
the painting is merely a pastiche of a seventeenth-
century portrait. In fact when it was painted in the
mid-1870s it must have appeared thoroughly up-to-date
with its subject inspired by the then highly fashionable
portraits of Frans Hals and a colour scheme of silver
set against yellowy-green which shows a knowledge of
Whistler's latest work.

It is interesting too that when Lord Leith could so
easily have acquired a genuine seventeenth-century
portrait he chose to buy the Pettie instead. As an
Edwardian he was not troubled by the late twentieth-
century preoccupation with historical authenticity. He
wanted his castle to be an attractive and comfortable
home where modern and antique craftsmanship could
happily combine.

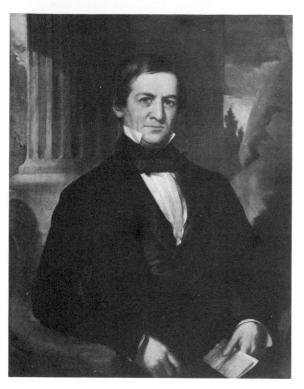

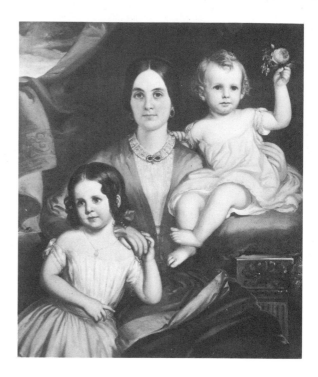

62

Derrick January

by *Manuel de Franca* (active 1839-1851)

oil on canvas 36×28¾ (0.910×0.730)

Signed and dated: De Franca 1851

63

Mrs Derrick January and Children

by *Manuel de Franca* (active 1839-1851)

oil on canvas 42×36 (1.070×0.910)

Signed and dated: De Franca 1851

Mr and Mrs Derrick January of St Louis, Missouri, were the parents-in-law of Alexander Leith later Lord Leith of Fyvie. He met their daughter Louise at a ball in San Francisco in 1870 and a year later they were married in Paris. The young couple settled in St Louis where Alexander started work in his father-in-law's iron and steel works. He soon became a steel magnate himself making a huge fortune, part of which he spent buying Fyvie Castle and in creating his collections of art and armour specially for it. These portraits of his wife's family are by a little-known American painter of Spanish descent. Louise herself is probably the elder of the two children.

64

The Silent Evening Hour

by *Benjamin Leader* (1831-1923)

oil on canvas 48¼×72½ (1.270×1.842)

Signed and dated: B W Leader 1900

Lord Leith showed almost no interest in contemporary art. Had he done so the Castle might have been filled with Gauguins and Cézannes. This hitherto unrecorded landscape is one of the few modern works he bought. It was not a particularly adventurous choice because by 1900, in Britain as well as in France, this type of large, atmospheric landscape was rather out-dated. Young British painters had abandoned this type of melancholic landscape popularised by Millais in the 1870s. They preferred smaller, more intimate scenes of humbler surroundings, which they painted with solid brush strokes and attention to subtle tonal differences.

65

Alexander Forbes-Leith, Lord Leith of Fyvie (1847-1925)

by *Ernest Breun* (active about 1900)

oil on canvas 46¾×56¾ (1.188×1.435)

Alexander Forbes-Leith was born at Blackford, close to Fyvie. He spent his youth in the Royal Navy but left it to settle in St Louis, Missouri, with his American bride. He made a fortune in steel and was active in

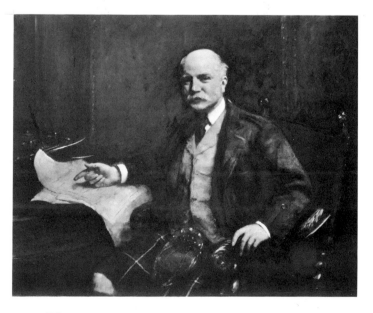

the consolidation of the industry and the formation of the United States Steel Corporation. Lord Leith could claim descent from several former owners of Fyvie and so when the Castle was put up for sale by the Duff-Gordons in 1889 he bought it and its rich contents for £175,000. He then proceeded to enlarge the Castle by building the Leith Tower and he enriched the collections of art and armour. Many of the paintings illustrated in this book were bought by him to decorate the Castle. In this portrait, commissioned from Ernest Breun, Lord Leith is shown wearing the tartan of Clan Forbes; his mother, the heiress of Blackford, was a Miss Forbes. Lord Leith points to a drawing of Fyvie showing the Leith Tower.

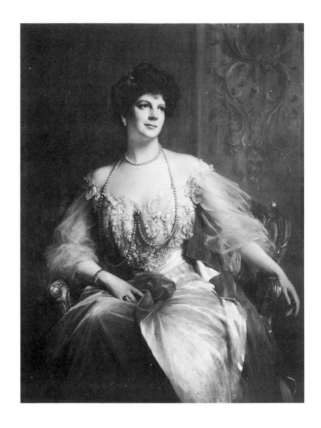

66

Lady Forbes-Leith (1872-1930)
by *Sir Luke Fildes* (1843-1927)
oil on canvas 55½×42½ (1.411×1.080)
Signed and dated: Fildes 1906

Ethel Louise Forbes-Leith was the daughter of Lord and Lady Leith of Fyvie. She must have inherited her father's administrative abilities for during the First World War, married to the local Conservative Member of Parliament, Sir Charles Burn, she ran with great effect the Stoodley Knowle Auxiliary Hospital at Torquay and was twice mentioned in despatches, awarded medals and made a Lady of Grace of the Order of St John of Jerusalem. Luke Fildes' opulent portrait shows her as an Edwardian society hostess. After the death of her brother and father she and her husband inherited Fyvie Castle. Under her father's will her husband assumed the name of Forbes-Leith. Her grandson Andrew, born just a few weeks before her death, sold the Castle and much of its contents to the National Trust in 1984.

Furniture, Sculpture, Ceramics and Glass, and Arms and Armour

Measurements are given in inches only. The following abbreviations are used:
h=height, l=length, d=depth, dia=diameter.

FURNITURE

67

Chest 1698

Scandinavian (?Norway), oak, carved with shallow panels of scrolling Nordic design, bound with iron straps, bearing the date 1698 carved on the front legs.

h 37in, l 64½in, d 24½in.

Such robust chests were used for clothes and linen. They probably originally held the textile portion of a bride's dower, hence the significance of the date, to commemorate betrothals or marriages.

68

(a) **Armchair 17th century style**

German, the back carved with two unidentified coats of arms, walnut with brocaded leather seat.

h 42in, l 23½in, d 21½in.

(b) **Armchair 17th century style**

German, the back carved with a panel of scrolling ornament, walnut with brocaded leather seat.

h 42in, l 22½in, d 21½in.

These may have started out life as a pair of simple seventeenth-century chairs with leather seats and 'slung' leather backs, of a common European form. Such chairs by the late nineteenth century would, very likely, have been in poor condition and this gave the nineteenth-century cabinet maker the opportunity to rebuild and 'improve' them, incorporating more elaborate ornament. The so-called 'Cordoba' leather seats, that were in reality probably of Low Country origin, originally started out as wall coverings, while the carved backs, including one with the rail dated 1665, follow no authentic prototype and date from the last quarter of the nineteenth century. A feature of Fyvie is a bedroom suite with genuine late eighteenth-century British furniture radically improved by elaborate all-over re-carving in the late nineteenth century.

69

(a) & (b) **Pair of hall chairs, 1730-1770**

Scottish or English, mahogany, the backs painted with the crests of Forbes (a bear's head and neck couped argent, muzzled asure) and Leith (a cross-crosslet fitchee sable) surmounted by a baron's coronet.

h 39in, l 17in, d 21in.

Such chairs with solid seats and inverted pearshaped backs are commonly met with in Palladian buildings and derive from the sixteenth-century Italian 'sgabello' form. A set of eight similar mahogany chairs was supplied by Alexander Peter of Edinburgh for Dumfries House in 1759 (Francis Bamford, A *Dictionary of Edinburgh Furniture Makers*, Furniture History Society 1983, pp. 94-100, pl 9). The crest is that of the 1st Baron Leith of Fyvie.

70

Cellarette, about 1820

Scottish or English, mahogany of vase form, with lead liner.

h 24in, dia 27in.

This piece of furniture would have stood under the sideboard, filled with ice on which would be placed bottles being kept cold. Ice would have been kept in an ice house on the estate.

71

(a) & (b) **Pair of tables, about 1740**

Scottish or English.

The oil gilded pine frames have scrolling legs carved with fish scale moulding and a leafy apron, supporting grey marble slabs.

h 32½in, l 48in, d 23in.

72

Table with marble top, about 1740

Scottish or English, the oil gilded pine frame carved with a Vitruvian scroll frieze, the fore-edge of the scrolling legs carved with money moulding, the sides with fish scaling.

h 33in, l 54½in, d 27in.

The type of this table and nos 71(a) and (b) is loosely associated with the name of the architect William Kent (1685-1748). In Scotland such Palladian furniture would have fitted out appropriately the grand apartments of a mansion by William Adam like Duff House or Hopetoun. All three tables were probably made by the same craftsman. The marble slab on no 72 is not original to the piece of furniture.

73

Commode, about 1785-1795

German, burr walnut with ebony stringing, of bombé form with grey marble top, and ormolu escutcheons.

h 36in, l 45½in, d 22½in.

The original escutcheons with cast festoons and vases in the Louis XVI taste would suggest a late eighteenth-century date.

74

(a)-(f) Set of six chairs, 17th century style

Scottish or Continental, walnut with tall backs elaborately carved and turned, with stuff-over seats covered with Flemish verdure tapestry.

h 51in, l 17½in, d 18in.

The style is loosely in the manner of Daniel Marot (working 1685-1718), William and Mary's favoured designer, but the date c 1865-75. The set appear in a lithograph by C F Kell of the drawing room at Fyvie, published in the Fyvie sale catalogue of 1885, before the Forbes-Leiths bought the Castle.

75

Rococo settee in the French taste, late 19th century

(?) French, walnut carved with 'S' and 'C' scrolls on hoof feet, the back covered in faded rose damask, the seat velvet.

h 38in, l 85in, d 27in.

The prototype is eighteenth-century French provincial but the date is late nineteenth-century.

76

(a)-(d) Set of four gilt chairs, late 19th century

French, Louis XV style, gilt wood with scrolling arms and cabriole legs, the seats and backs covered in tapestry.

h 30in, l 21½in, d 22in.

77

'Bureau à cylindre', about 1890

French, mahogany with ormolu leafy mounts and lion's paw feet.

h 48in, l 59in, d 34in.

Based on a grand piece of French transitional furniture c 1775-80.

78

'Aesthetic Movement' clock in ebonised case, about 1880

English or French, with matted and burnished brass dial with a sunflower and other floral motifs.

h 20in, l 10½in.

The style is reminiscent of Lewis F Day (1845-1910) but the clock movement is French and signed:
E. LOUNDEL ET BISGOU.

79

(a)-(f) Set of six hall lanterns, in part late 17th century

Venetian, the beaten copper lanterns with domical covers surmounted by banners charged with the Lion of St Mark, gilded, the timber poles covered with crimson velvet.

h (of copper section) 52in.

These seem to be a set of four lanterns, extended to six in the late nineteenth century. Such items were propped in entrance halls, fixed to boats or held by servants. These may have come from the Ducal Palace, Venice.

SCULPTURE

80

Bust of the Emperor Caesar Augustus (63 BC-AD 14)

White marble head on peach coloured marble shoulders and torso. Italian (? Florentine) late 19th century.

h 31in, w 19in.

The chasings of the corselet display a group of personifications indicating sunrise – Sol, Caelus, Aurora and the goddess of the morning dew – as well as Diana and Mars. Such good quality copies of the Antique have been carved in Italy from the sixteenth century until the present day. The bust is copied faithfully from the Prima Porta statue of the Emperor discovered in 1863 in the Villa of Livia and now in the Braccio Nuovo of the Vatican Palace, Rome.

81

A Racehorse – St Simon

by *Sir Joseph Edgar Boehm* (1834-1890)

Bronze, inscribed on the front of the plinth: ST SIMON; on the back: DOBSON 110 NEW BOND ST W. and signed at the back: E. Boehm/1885.

h (overall) 22in, l (of base) 18½in, w (of base) 5in.

St Simon, by Galopin out of St Angela was the greatest racehorse on the English turf. He won the Derby in 1885 for the Duke of Portland. Boehm, of Hungarian extraction, was a rather unimaginative and dull sculptor who was highly regarded by Queen Victoria and especially Lord Rosebery, the Prime Minister. He carved the colossal statue of Queen Victoria at Windsor, the monument to General Gordon in St Paul's Cathedral and the equestrian statue of the Duke of Wellington at Hyde Park Corner.

CERAMICS AND GLASS

82

(a)-(e) 'Garniture' of five vases, about 1830

Cut glass, English or Irish.

Such 'garnitures', or graded sets, were made to dress chimneypieces or buffets.

83

(a) & (b) Pair of three light lustres, about 1780

Cut glass, English or Irish.

This very fine pair of candelabra would have been intended to stand in the corners of a room on tripods, or on console tables between windows with looking glasses behind, so positioned to maximise the light thrown by the candles and reflected by the many facetted glass.

84

Table lamp with leaded stained glass shade, about 1890

American, New York, Tiffany studios. A mushroom shaped six-light electrolier, the green patinated bronze pillar swelling towards the base ornamented with moulded onion-like plants, the shade formed by a myriad of brightly coloured daisies in full bloom.

h 32in, d 23in.

A magnificent example of Tiffany glass and probably the most important decorative art object remaining at Fyvie. Friends of the Forbes-Leith family in New York commissioned from the Tiffany studio a stained glass three light window representing St Michael for Fyvie Parish Church as a memorial to Lieut Percy Forbes-Leith who died of enteric fever aged nineteen in the Boer War on 31 December 1890 (see photograph displayed nearby, discussed in A M W Stirling, *Fyvie Castle*, London, 1928 pp 401-402, repr p 402). The lamp probably dates from the same period.

ARMS AND ARMOUR

85

A Cap à Pie suit of plate armour, about 1540

German. Globose breastplate with lance rest, roped turnover and movable gussets, pauldrons with laminated fan plates, complete arms, gauntlets, lobster cuisses, jambs, solerets, close helmet, the whole engraved with vertical lines which have originally been gilt. From the collection of Lambourne Place and Pocklington Hall, Waplington, Yorks.

Lit: *Catalogue of Arms and Armour at Fyvie Castle, Aberdeenshire*, privately printed, nd, p 2, repr.

86

A Cap à Pie suit of bright steel armour, about 1550

German. Engraved with foliage in vertical bands, consisting of close helmet, breast and back plates, pauldrons, reve and vambraces, elbow pieces, finger gauntlets, tassets of six plates, cuisses, jambs and solerets.

Lit: *Catalogue of Arms and Armour at Fyvie Castle, Aberdeenshire*, privately printed, nd, p 3, repr.

87

(a) & (b) Two halberds, about 1540

Probably German, steel with timber shafts.

Lit: *Catalogue of Arms and Armour at Fyvie Castle, Aberdeenshire*, privately printed, nd, p 7.

88

(a) & (b) Pair of flint lock pistols, about 1770

Scottish, engraved steel, inlaid with silver, ramshorn butts. Signed by John Campbell of Doune.

A bill for these is still at Fyvie. They were bought from Fenton & Sons, 11 New Bond Street, April 1907, for £20.

Lit: *Catalogue of Arms and Armour at Fyvie Castle, Aberdeenshire*, privately printed, nd, p 17.

89

(a) & (b) Pair of flint lock pistols, about 1780

Belgian, with steel barrels and mechanisms, walnut stocks, the butts ornamented with lion masks.

90

A claymore, about 1480-1500

Scottish, steel with drooping quillons.

It was this sort of mighty two-handled sword that would have been wielded at Bannockburn. The name derives from *Claidheamh mór*, or great sword.

91

Broadsword, about 1765-1770

Scottish, with chased and pierced basket hilt.

This may well be the sword held by Colonel William Gordon of Fyvie in Batoni's portrait of 1766 hung nearby. Alternatively it may be one of the Scotch

swords' for which a bill survives at Fyvie from Fenton & Sons of 11 New Bond Street, in September 1899 for £27. The peculiar form of the Scottish basket hilt derives from the Venetian pattern known as *Schiavone*.

92

Pair of flint lock duelling pistols, about 1810

French.

These pistols are said to have been presented by the Emperor Napoleon to General Caraigear.

MISCELLANEOUS

93

Head of a moose, stuffed

94

(a) & (b) **Pair of mounted antlers**